IMAGES
of America

WYANDOTTE

D1127841

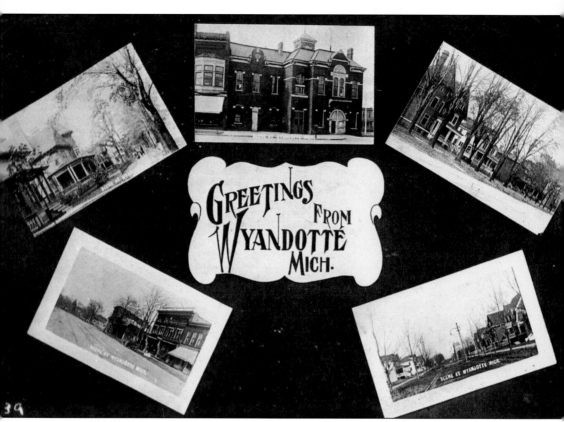

Wyandotte has enjoyed the reputation of being a warm and welcoming community for visitors to the Detroit metropolitan area. Located along the Detroit River on an international waterway across from Canada, Wyandotte quickly became nationally recognized as the birthplace of the first steel rails for the rapidly growing American railroad industry and continued to contribute significantly over the years to the industrialization of the country. (Wyandotte Museum.)

On the cover: Maple Hall served as a social hall for the citizens of Wyandotte. Located at the corner of Third Street and Maple Street, this building witnessed many local celebrations, political events, and speeches. At one time in its history, the hall's second floor was used as classroom space for St. Joseph's school until its new building was constructed. (Wyandotte Museum and Bacon Memorial District Library.)

IMAGES
of America

WYANDOTTE

Ken Munson

ARCADIA
PUBLISHING

Published by Arcadia Publishing
Charleston, South Carolina

Printed in the United States of America

Library of Congress Catalog Card Number: 2006935952

For all general information contact Arcadia Publishing at:
Telephone 843-853-2070
Fax 843-853-0044
E-mail sales@arcadiapublishing.com
For customer service and orders:
Toll-Free 1-888-313-2665

Visit us on the Internet at www.arcadiapublishing.com

*This book is dedicated to my wife, Louise, for her continuing
support, encouragement, and assistance during the production
of this work. Also, this book is dedicated to the members, past and
present, of the Wyandotte Cultural and Historical Commission
and Wyandotte Historical Society.*

CONTENTS

ACKNOWLEDGMENTS

My special thanks to the Wyandotte Cultural and Historical Commission and the Bacon Memorial District Library for their cooperation in allowing me to research their archives and for providing permission to use these photographs for this book. In addition, I extend special gratitude to Jody L. Chansuolme and Nathan Gambino of the Wyandotte Museum and Janet Cashin and Wallace Hayden of the Bacon Memorial District Library for their valuable assistance in locating and preparing photographs from both of their archival collections.

INTRODUCTION

The Wyandott Indians originally made their home in Canada in the Georgian Bay area. In 1732, members of a remnant tribe of Hurons who called themselves Wyandotts found their way to this region after following the French and Cadillac Indians to Detroit. The river shore along the Detroit River offered the Wyandotts easy access to water and wooded areas as well as rich hunting and fishing and proximity to the Canadian area. It was in this region that the Wyandott Indian village of Maquaqua was established. During this time there were also a few white farmers living in the region. The area provided a hunting region that offered deer, partridges, pigeons, bear, wild duck, geese, and turkeys and was also rich in wooded areas.

After several earlier treaties that continued to move the Native Americans farther west, the Wyandotts were required to relinquish their claim on their rich land to the United States government. This area, which was eventually to become known as the city of Wyandotte, consisted of small orchards, cornfields, and a few houses.

In 1818, Maj. John Biddle, a retired United States Army officer, came to the Wyandotte area and purchased over 1,200 acres of this rich land from the United States government upon which Maquaqua formerly stood. His property holdings during the first years the land became available for sale was two miles long by two miles deep. He developed acreage for some farming and built a home, referring to it as his "Wyandotte Estate."

In 1853, Biddle sold his land to the Eureka Iron Company, which was seeking a factory site. The Eureka Iron Company surveyed the land, declared the boundary lines, and established a village in the office of the Wayne County Register of Deeds on December 12, 1854. Since this new village included the acreage of the original property, it was named Wyandotte from the title of the estate, and Biddle was soon declared to be the city's first white man to have formally settled in the area. In later years, Biddle served as mayor of the city of Detroit, delegate of the territory in Congress, the first president of the Michigan Central Railroad, and several other public service positions.

The streets of the village were based on a plan of the Philadelphia pattern originated by William Penn. Penn designated one boundary line of Front Street as the starting point. Since Wyandotte had a riverfront, the main focal point of the area became the river, and the first street parallel to it became Front Street. The streets running parallel to those became numbered streets (First, Second, Third, and so on), and streets running horizontal to it were named for plants and trees (mulberry, chestnut, oak, and so on) in accordance with the Quaker respect for botany.

Wyandotte represents the usual melting pot of multiple nationalities. The predominant nationality groups from 1854 to 1880 have been the English, French, Irish, Scotch, Canadians, Germans, and Poles. After 1880, there was an influx of nationalities, including Hungarians, Greeks, Serbs, Armenians, Russians, Czechs, Slovaks, and Italians. Most nationalities came to Wyandotte during the same periods that marked the immigration story of the United States.

The city of Wyandotte today, after recently celebrating its sesquicentennial, continues to grow and change from an industrial and shipbuilding riverfront community to that of a more recreational community with condominiums located on the riverfront and a revival of historic preservation of period homes dating from the 1850s to the early 1900s. In addition, the city's residents recognize the importance of the role history, culture, and the arts have played in the growth and development of their community. They actively work through city commissions, their local historical society, and numerous arts and civic groups to retain and maintain an environment dedicated to the ongoing growth of culture and economic development.

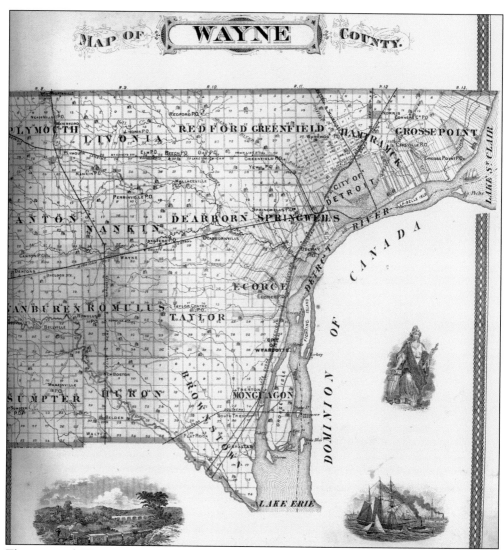

This map of Wayne County, as illustrated in the 1876 *Illustrated Historical Atlas of the County of Wayne Michigan*, shows the location of Wyandotte in relation to the surrounding southeastern Michigan communities, the Detroit River, Lake Erie, the city of Detroit, and Canada. (Wyandotte Museum.)

One

THE EARLY RESIDENTS AND A GROWING COMMUNITY

In 1760, the French surrendered this area to the British, and in 1796, it became a part of the United States. Gen. Anthony Wayne was appointed commander in chief of the United States armies and arrived in Detroit in August 1796, and, as a result of his presence, the residents named the county after him. In 1805, Gen. William Hull became governor of the Michigan territory. During the 1800s, the names of George Clark, William Case, and George Payne were recorded in the area as farmers. According to an early interview with Clark, the homes in the area were made of hewed logs. The creeks and swamps were abundant with frogs, snakes, and fish, and many wolves and deer roamed the land. Case purchased land in Wyandotte during the 1820s and 1830s, and Payne purchased property that fronted on the Detroit River. Payne raised cattle and sheep when Native Americans were still residing in the area. Early resident recollections indicate that the Native Americans were friendly and often dined with the settlers. Immigrants from other countries began to search for a better life in the United States. By the 1850s, the Irish and English started to settle in the Wyandotte area, and in the early 1860s, the Germans started to arrive. It is difficult to obtain early specific information on the immigration as there is a lack of written source material. Many facts have to be deduced from the general history of the community, from interviews with local pioneers, from the general history of immigration in the United States, and from the nationality history of the Detroit area.

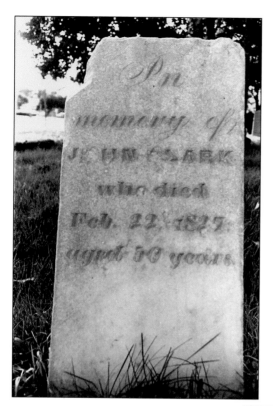

John Clark's family moved into a small house on the site of Maquaqua, or Monguagon as the French called it, in approximately 1819. His family lived a farming existence until 1827 when he moved to another part of the region to develop a new farm in Brownstown. This new farming adventure was short-lived as he died on February 22, 1827. (Bacon Memorial District Library.)

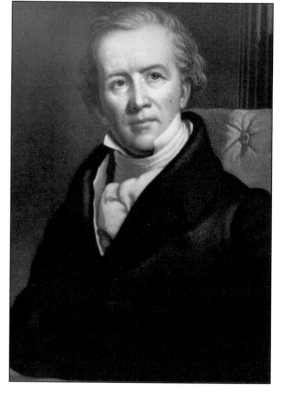

Maj. John Biddle's home "the Wyandotte" was completed in 1835, and in 1836, he and his family moved from the city of Detroit to Wyandotte. The home was located at the present site of Biddle Avenue and Vinewood Street in the city and was an imposing structure with a wide veranda running its entire length with Corinthian columns reaching to the house's second story. Biddle lived in his home from 1836 to 1848, but he was not a farmer and longed to return to the military and public life. He left the Detroit area and returned to Philadelphia. (Wyandotte Museum.)

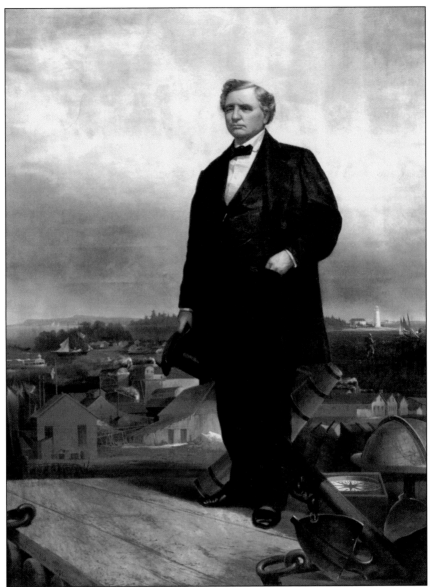

In 1853, an insurance agent and businessman in Detroit traveled to the Lake Superior area in Michigan and learned of hematite iron ore of a very high quality. He had samples of the ore tested and later smelted in a bloomery. The tests returned superior-quality results, and he immediately returned to Detroit and interested some fellow capitalists, including Eber B. Ward, who arrived in the Detroit area in 1821. At the age of 12, he was sailing on the Great Lakes for his uncle, who was an owner of a large number of vessels. As there were no railroads in those days, steamboating became immensely profitable. Gradually, as railroads began to spread out toward the West, he devoted his interests to iron manufacturing. By 1860, America's railroads were largely dependent on domestic iron or steel rails imported from England, which exported inferior quality to America. Ward set out to remedy this problem, which forged the way for the Industrial Revolution. He was the giant industrialist of the Northwest from 1840 to 1875 and was a superior financier and organizer. On October 15, 1853, the Eureka Iron Company was officially organized. Ward proceeded to lay out the village of Wyandotte. (Wyandotte Museum.)

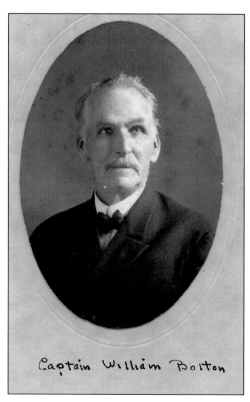

Capt. William Bolton contracted with Eber B. Ward to transport building supplies for the construction of the Eureka Iron factory. As a result of his many visits to the village of Wyandotte and the realization of the importance of using the Detroit River for transporting supplies, Bolton decided to build a home in Wyandotte in 1855. As a result of Bolton's frequent visits as a transporter, local residents soon recognized that the river meant as much to the continuing development of the new village as the land itself. (Bacon Memorial District Library.)

Captain William Bolton

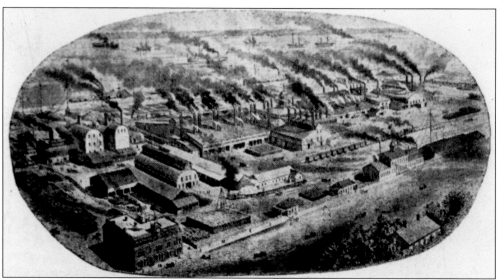

The Eureka Iron plant, which once occupied the site of the Wyandott Indian village of Maquaqua, was the major industry in the village and operated from 1854 to 1892. The furnaces were built of stone brought to the land site by Bolton by way of the river. The two furnaces and a rolling mill consumed approximately 6,000 bushels of charcoal each day and over two million bushels a year, or about 50,000 cords of wood. In those days, the constant sound of the felling of trees was a positive sign that the mill was running and people were at work. In later years, coke replaced the use of charcoal. (Wyandotte Museum.)

In 1864, the first steel ingots were made by the Bessemer steel process, which used a method developed by an American, William Kelly, but named for Sir Henry Bessemer. The next year, the first Bessemer steel rails were rolled at the Wyandotte mill. These were the first steel rails produced in the United States and the beginning of the steel industry in America. Kelly's process was quickly adopted by companies in other states. Since they had easier access to coal, coke, and natural gas, fuels that proved to be much better than charcoal, they were able to produce a cheaper product than the company in Wyandotte. (Bacon Memorial District Library.)

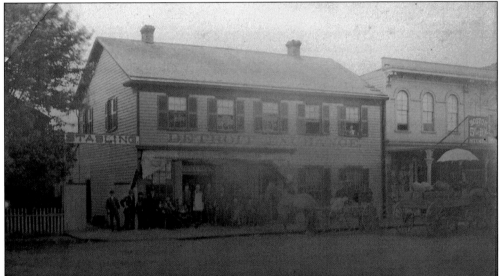

As the community continued to grow, corporate management realized the need for laborers to keep the mills operating and sent agents to Europe to "sell" America to emigrants. Wyandotte advertising posters were also placed in New York City, the port of entry for immigrants. As the population grew, there was a growing need for lodging. The Detroit Exchange Hotel in Wyandotte was located between Oak and Elm Streets on the east side of Biddle Avenue. Milspaugh's Stables was located on the left. This establishment provided a welcome relief for travelers after a day of dusty air and muddy roads. (Wyandotte Museum.)

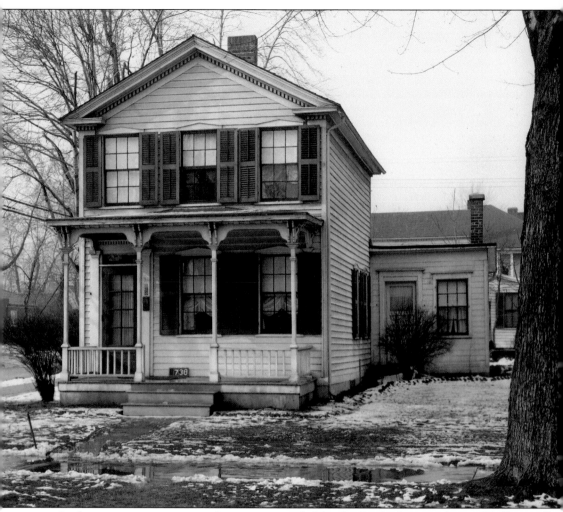

As the community grew, more homes were needed for the Eureka Iron employees. "Rolling mill houses" were built during the early years of the village by the Eureka Iron Company. Credit for the first house constructed in Wyandotte has been shared by Leander Ferguson and Michael Boucher, who originally came to Wyandotte to run a boardinghouse for employees of Eureka Iron and Steel and built many of the city's early buildings. This rolling mill house with Greek Revival accents, built in 1857 on Superior Boulevard and Second Street, is typical of the workers' homes from that period. It was owned by R. C. Conwell, a Wyandotte shipyard superintendent who was one of the first city aldermen in 1867, the city treasurer in 1878, and also an alderman in 1889 and 1890. The house continues to stand on its original site at 166 Superior Boulevard. (Wyandotte Museum.)

Two

EARLY BUSINESS AND INDUSTRY IN THE DEVELOPING CITY

Prior to 1866, Wyandotte had existed only as an unincorporated village and an integral part of Ecorse Township. Incorporation papers to become a city were filed in December 1866 and approval by the legislature was delayed until March 5, 1867, because they had recessed. The election of officers was held on the first Monday of April 1867, and under the first aldermanic charter government, the city was defined as it was in the village days with the land divided into three wards. As a full-fledged city, Wyandotte welcomed new businesses and the expansion of existing businesses and industry. Wyandotte's waterfront that had served the village so well soon became even more important to the continuing growth of the city. Multiple steam and sail vessels could be seen at any time of the day on the Detroit River, bringing travelers and raw materials from other areas of Michigan as well as from other states in the country. The photographs that follow are a sampling of the many varied businesses and industries in the community that made Wyandotte a lively hub of commerce throughout the 19th and 20th centuries.

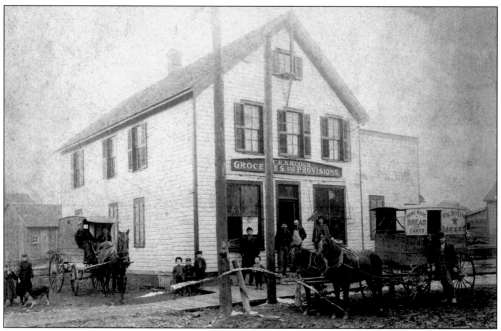

In 1888, Charles E. Kreger moved his grocery store to Biddle Avenue and Pine Street in Wyandotte from Taylor to be near the waterfront. Note the bakery wagon with the sign promoting homemade breads and cakes as well as the wooden sidewalks and dirt road. A grocery store often served local residents as the information center for news and current events. (Wyandotte Museum.)

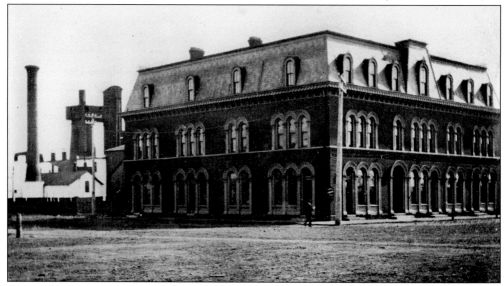

This is the Wyandotte Savings Bank building with Eureka Iron Works in the rear in the late 1880s. This building was built in 1860 as the office of Eureka Iron and Steel. Before the bank was organized, Eureka Iron had to transact all of its business in Detroit. The bank was founded in 1871 by John Van Alstyne, who served as manager of Eureka Iron, and stands at the corner of Biddle Avenue and Elm Street today. The north side was used for the bank and the south side used for the offices of Eureka Iron. The third floor was used for school plays, lectures, dances, and graduations. (Bacon Memorial District Library.)

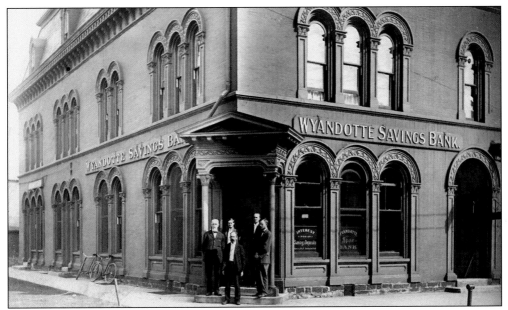

The Wyandotte Savings Bank building was also used for concerts, and from time to time, organizations such as the Masonic lodge and Sons of Rest used the hall on the third floor as club rooms. Today the building is the oldest business building in the city. The Wyandotte Savings Bank survived the Depression and remained in business into the late 20th century. (Wyandotte Museum.)

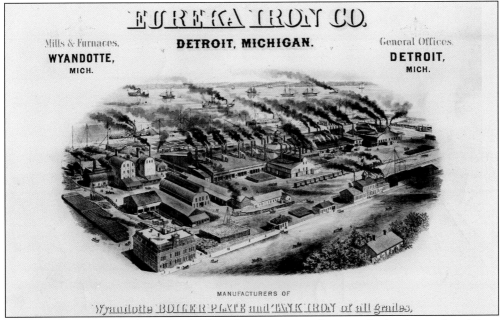

A bird's-eye perspective shows Eureka Iron Company, manufacturing boilerplate and tank iron of all grades. The blast furnace was located just south of Elm Street. As the company progressed and changes in the industry occurred, shipyards and rolling mills were added. Until 1871, the furnace and rolling mill provided the main means of livelihood for local residents. (Bacon Memorial District Library.)

This is the Eureka Iron Works dock where the blast furnace was located. At the far left of the photograph, the angled roofline of the third floor of the Old Main Building that served as the Wyandotte Savings building for most of the 20th century can been seen. The building still stands (minus the third floor) at Biddle Avenue and Elm Street. The docks later became the Van Alstyne Boulevard area. (Bacon Memorial District Library.)

Workmen at the Wyandotte Eureka Iron and Steel rolling mill in 1890 worked long hours and were devoted to their employer. In 1870, the city ranked eighth in steel output in the United States. The rolling mill was built for the purpose of rerolling iron into iron rails. It was the first mill in the country west of the Allegheny Mountains. (Bacon Memorial District Library.)

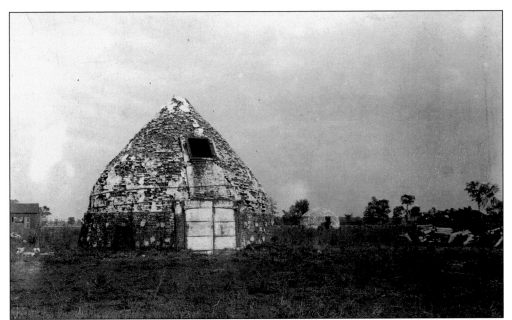

It was a major job to keep two furnaces and the rolling mill stocked to keep the fires roaring. Large logs from fallen trees were placed in kilns or iron retorts. These units were located south of Wyandotte and along Eureka Road. The kilns were fired, and the coverage and earth restricted the air supply so the wood would not completely burn to ash. They formed a charred ash fuel that was then transported by wagon to the furnaces. (Bacon Memorial District Library.)

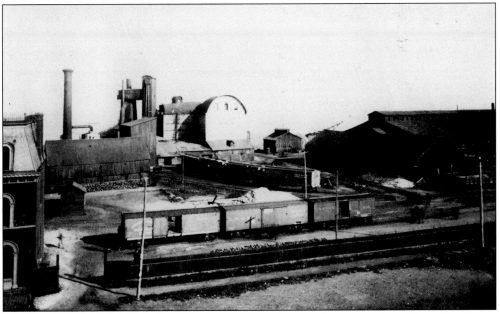

The Wyandotte rolling mill of Eureka Iron and Steel covered an area of land from Elm Street to Maple Street. The mill gave employment to a large number of skilled workmen at liberal wages. The first rail mill was adapted for the rolling of rails at the standard length of 21 feet long. After a few years, the standard length was changed to 30 feet, the mill was modified, and the operations of the mill proved to be quite profitable. (Bacon Memorial District Library.)

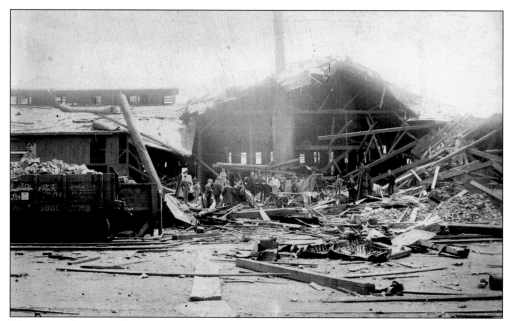

The panic of 1873 and competition from other iron manufacturers caused considerable financial strain on the company. Workmen were paid at the mill in scrip in values of $2, $5, $10, and $20 bearing seven percent interest and signed and dated by Eber B. Ward. Local Wyandotte merchants cashed them at a discount of 40 percent. Another major tragedy was about to dictate the future of the company. In June 1888, a boiler exploded at the plant that shattered the windows and walls of homes and stores. As a result of this explosion, lack of cheap fuel, business competition, and labor problems, the industry collapsed. (Bacon Memorial District Library.)

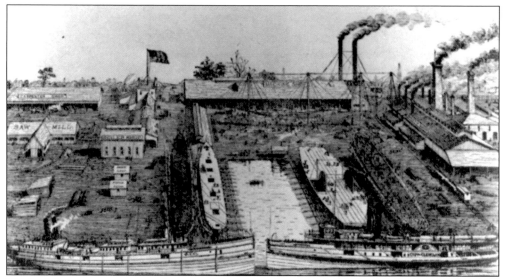

Shipbuilding was an active industry in Wyandotte from 1871 to 1919. Many vessels were built in the Wyandotte yard along the Detroit River. Capt. Eber B. Ward became acquainted with Frank E. Kirby, who knew much about naval architecture and commissioned Kirby and his brother to erect the necessary structures, prepare the plant for operations, and proceed to construct the largest iron tug ever built. (Wyandotte Museum.)

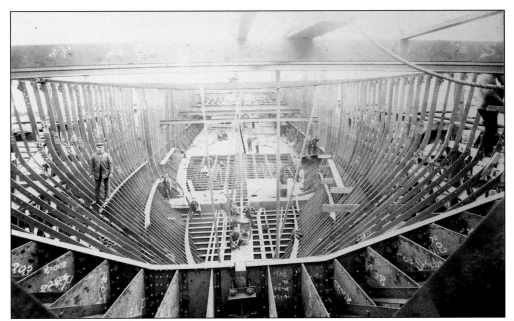

The first iron boat built in the Wyandotte yards was the *E. B. Ward*, completed and launched in August 1872. There were three other ships built during the same season, including the *Myrtle*, the *Queen of the Lakes*, and the *Sport*. This photograph illustrates the immensity of the ship and the importance of building it as close as possible to water for easy launching. (Wyandotte Museum.)

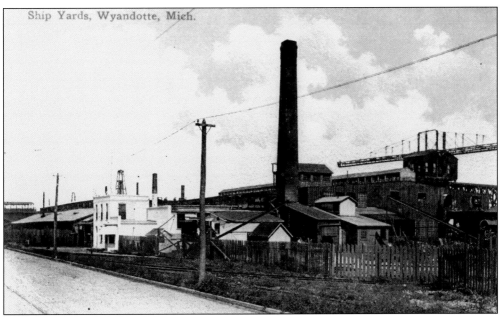

A postcard of the Wyandotte shipyards shows the company buildings and grounds on the banks of the Detroit River. The Wyandotte plant was for hull construction. The ships were moved to the Detroit plant for finishing. The finishing would include the boilers, upper works, and machinery. (Wyandotte Museum.)

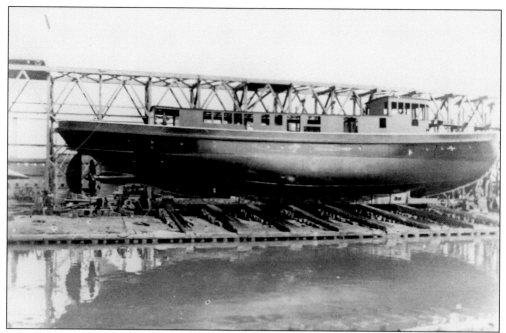

A boat under construction on "ways" in 1890 is seen in this image. All the materials used in the construction of these boats were made under specifications developed by the company. Frank E. Kirby was very careful in his selection of appropriate steel material, as was shown in his steel regulation drawings. (Bacon Memorial District Library.)

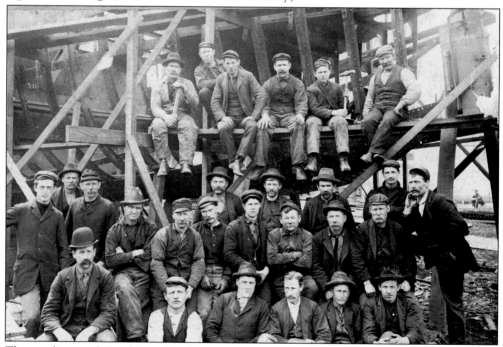

The employees of the shipyards take a moment to pose for a photograph. These men were proud of their positions with the company and held themselves to high-quality standards in construction. (Wyandotte Museum.)

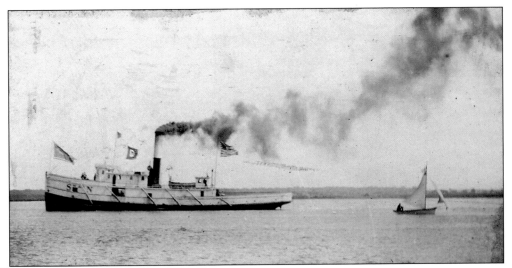

The *John Owen* was launched in June 1889. This ship was built under the auspices of the Detroit Dry Dock Company. The machine shop and docks were on the Detroit River at the foot of Plum Street. (Bacon Memorial District Library.)

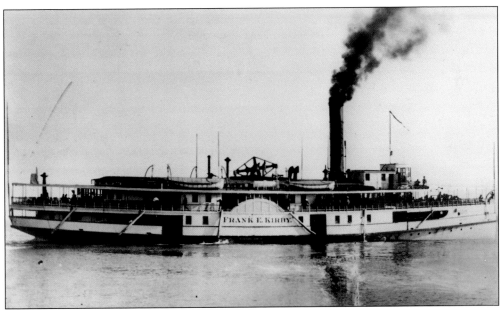

The *Frank E. Kirby* was built and launched in Wyandotte on February 12, 1890. The ship was used for many years for excursions, picnics, and special celebrations. Every church, lodge, and school boarded the *Frank E. Kirby* at one time or another for their outings. It ran a route from Wyandotte to Put-in-Bay for many years. (Bacon Memorial District Library.)

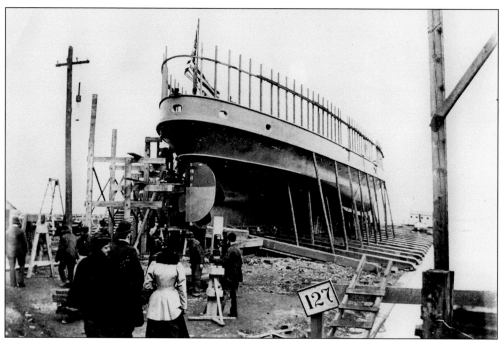

It is an exciting moment as the crowds assemble and the *America* is set for launching. Many times children were dismissed from schools in the later afternoons so they could witness the launching of the most recently completed ship's hull. (Bacon Memorial District Library.)

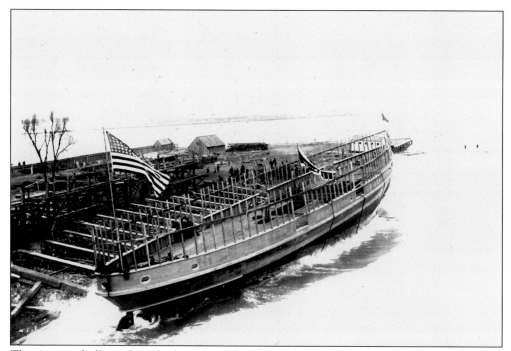

The *America* hull was launched on April 2, 1898, and is unfinished in this photograph. The ship was moved to Detroit for the final finishings and mechanical equipment. (Bacon Memorial District Library.)

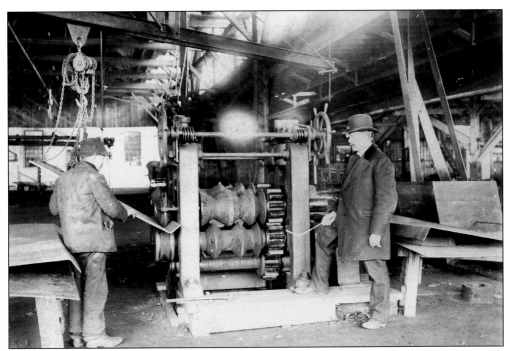

An interior photograph shows one of the buildings in the shipyards of the Detroit Dry Dock Company. Shipyard workman Anthony LeBoe (left) and supervisor Fitz Kirby, brother of ship designer Frank E. Kirby, discuss the next building project. (Bacon Memorial District Library.)

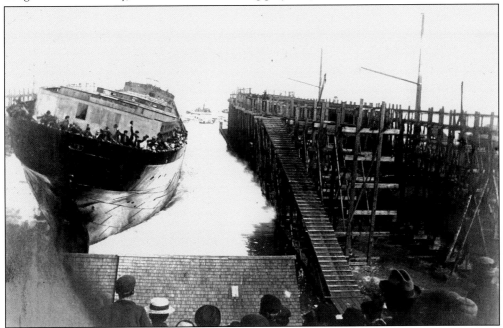

The *Angeline* was launched in September 1899. Looking closely at the photograph one can see a number of citizens on the ship's deck for the launching. Elaborate scaffolding had to be constructed at great heights to gain easy access to the hulls of the ships under construction. (Wyandotte Museum.)

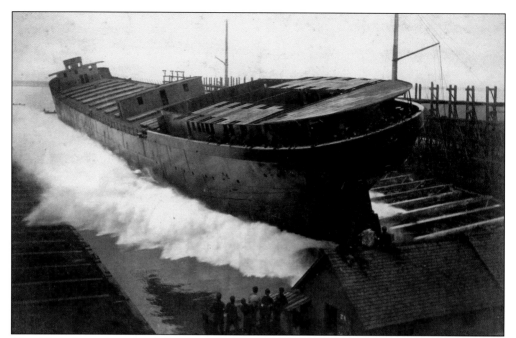

The *Admiral* was the second ship launched under the American Shipbuilding Company trust. The American Shipbuilding Company, a trust composed of several companies, including the Detroit Dry Dock Company, took over management of the shipyards. The ship was built for the American Steamship Company with M. B. McMillan as chief owner. (Wyandotte Museum.)

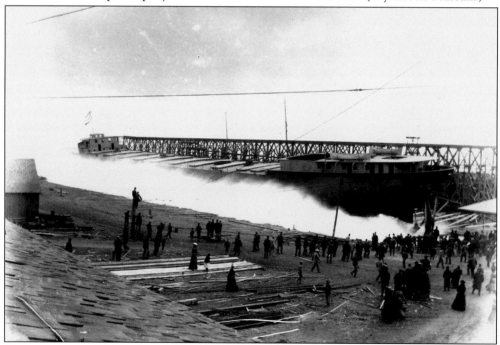

The citizens turned out in great numbers to watch this ship launched from Plum Street. It appears that no guests were on this ship when it was launched, an unusual happening since many of the other launchings allowed residents to be on the ship during launching. (Wyandotte Museum.)

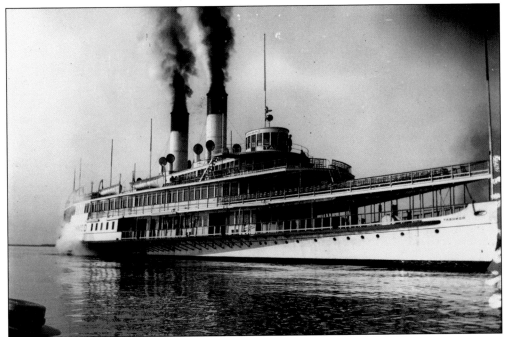

The *Tashmoo* was launched from the Wyandotte shipyards on December 30, 1899. It was an excursion boat that traveled to various points on the Detroit River and was also used for private excursions. On one such excursion, the *Tashmoo* struck a rock and put a hole in the hull. The ship was able to dock in Amherstburg, Ontario, unload the passengers, and then sunk in the mud. (Wyandotte Museum.)

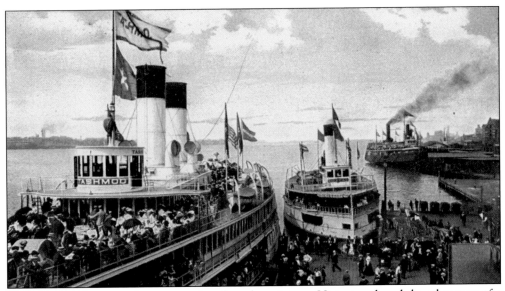

The Detroit River waterfront was a site of much activity as Victorians loved the adventure of a special excursion. Residents from Wyandotte and southeastern Michigan enjoyed a trip on the Detroit River especially during the hot summer months when temperatures could be as much as 15 degrees cooler on the water. Efforts to raise the *Tashmoo* from the mud failed, and the ship was scrapped in 1937. (Wyandotte Museum.)

The camera captured another momentous day in the life of a Wyandotte resident, offering citizens the opportunity to socialize with one another at a boat launching. The ladies always wore elaborate hats, as was the style of the period, and they often brought parasols with them to protect them from the heat of the sun on a hot day. (Wyandotte Museum.)

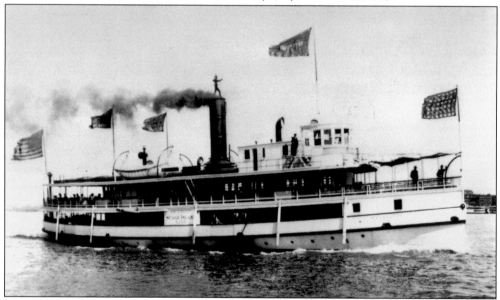

The *Wyandotte* was the first boat to be named in honor of the city. Launched in 1892, the boat left at 7:45 a.m. and returned from Detroit at 4:00 p.m. on a daily basis. Wyandotters enjoyed the ride to Detroit and back. The fare was 8.5¢ when tickets were purchased in lots. The ticket rate never exceeded 50¢ for a round-trip. In May 1904, the management of the steamer *Wyandotte* found it advantageous to abandon the route as a result of the new street railways now leading into the city of Detroit. (Wyandotte Museum.)

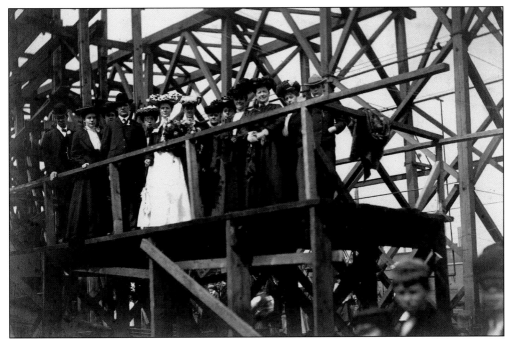

The Wyandotte shipyards played an important role in the everyday life of Wyandotte citizens. This event, captured by the camera in the shipyards located on the Detroit River at the foot of Plum Street, utilized the scaffolding platform that stood nearby the launching point for the many fine ships built in the city. In this photograph, it is difficult to determine whether the participants were celebrating a launching or taking pictures for their wedding album, as the lady in the center holds a bouquet of flowers. (Wyandotte Museum.)

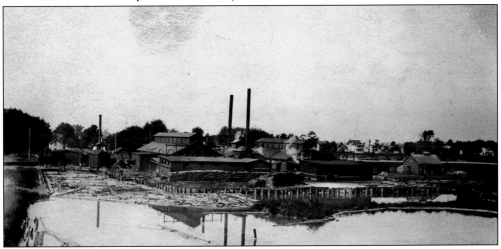

In addition to the shipyards and the iron and steel industries, Wyandotte was also home to the D. H. Burrell Hoop and Stave Company. The Wyandotte plant was established in 1885 with one mill moved from Trenton, Michigan, and another from Detroit joined into one plant. The Wyandotte facility had four distinct mills: one making barrel hoops, one for cheese box and barrel headings, one for staves, and another for cheese box hoops. The Wyandotte works was a division of D. H. Burrell's hoop and cheese box material factory in Little Falls, New York. (Wyandotte Museum.)

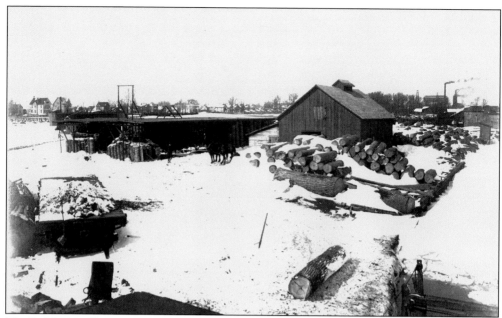

The D. H. Burrell Company heading mill and drying yards in Wyandotte are captured in this early photograph. Elm logs were plentiful in this region and were hauled by teams from the neighboring woods and farms in the Downriver area. Logs were also floated down the river from Chatham through Lake St. Clair and from the province of Ontario, Canada, as well. (Wyandotte Museum.)

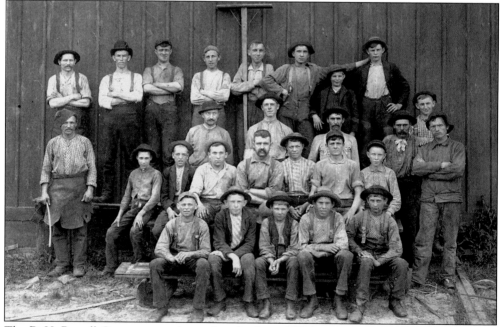

The D. H. Burrell Company was located at the foot of Walnut Street near a marshy area that was dredged to make a holding and storing area for the logs. The plant provided employment for 125 men, and this photograph shows some of the employees of the company taking a break for a picture. (Wyandotte Museum.)

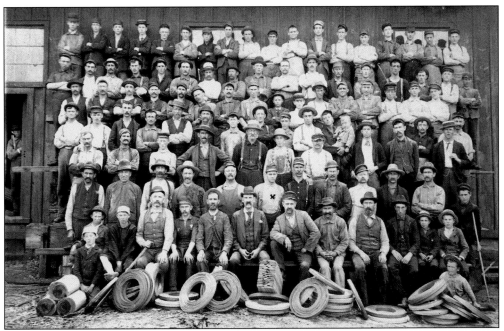

The D. H. Burrell Company hoop and stave mill employees pose for a photograph. The workers chose to display their wares on the ground in front of them. On the left of the photograph it appears someone was camera shy and decided to stand in the doorway instead of being seated on the bleachers. (Wyandotte Museum.)

A new type of hoop machine was created by several workmen at the D. H. Burrell Company. A patent was granted to the company, and it proved to be the most rapid and economical hoop-cutting machine in the industry, cutting the hoops from the log on a bevel with a knife long enough to cut the length up to six feet nine inches from the circumference to the center of the log. The old method called for cutting logs into planks and then cutting the hoops from the planks, which resulted in hoops not being of uniform thickness. (Bacon Memorial District Library.)

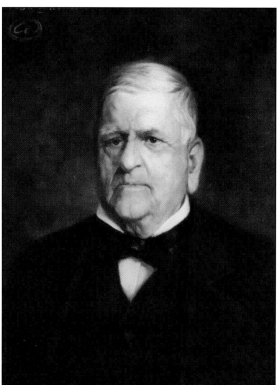

J. B. Ford, founder of the American plate glass industry, purchased large tracts of land south of Wyandotte along the Detroit River to be divided into building lots for manufacturing purposes. Ford had learned of a rich deposit of salt in the Wyandotte area. Salt was needed in the making of soda ash, an important component in glass production. This led Ford to found the Michigan Alkali Company. (Bacon Memorial District Library.)

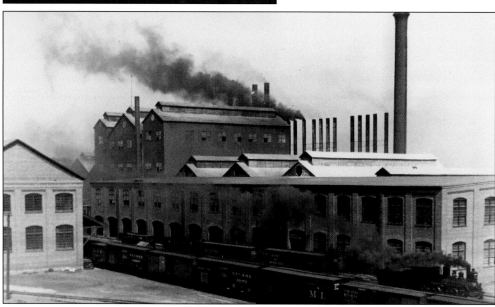

The Michigan Alkali Company was organized in 1890 and nine years later was firmly based in Wyandotte. Its primary objective was the manufacture of soda ash, a necessity in the production of soap and glass. In 1898, the J. B. Ford Company was organized to use the alkalis for products to be sold in small quantities suitable for household use. The company soon expanded into the production of baking soda and caustic soda. In 1942, the Michigan Alkali and Ford divisions were incorporated as the Wyandotte Chemicals Corporation. (Bacon Memorial District Library.)

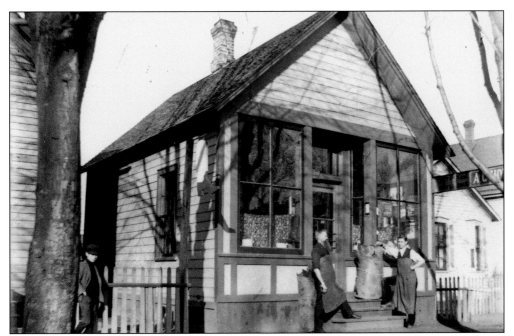

Over the years, Wyandotte continued to grow as many new businesses opened in the community. Among these was August Hoffman Shoes, in business from 1880 to 1917. A pair of shoes in 1880 could be purchased for $2 and generally took a couple days to make. Hoffman is pictured on the left with his son Louis on the right. (Wyandotte Museum.)

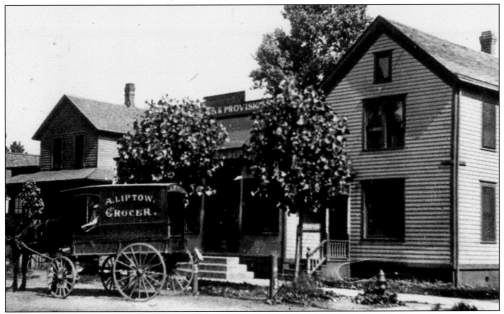

The Liptow egg station and store were located at the corner of Pine and Fourth Streets. Years before the age of supermarkets, butter and egg stations were quite common until the 1930s–1940s. Many times there were small grocery stores also incorporated into the business. The establishment had been continuously operated by the Liptow family for over a century. (Wyandotte Museum.)

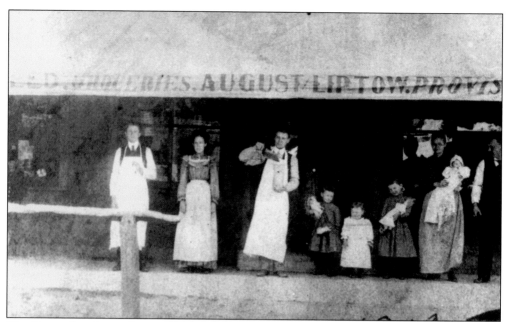

The Liptow family stands outside of the store, which was located in the old German section of Wyandotte, in 1903. The building opened as a tavern around 1879. In 1883, the family converted the tavern into a general store that sold everything. (Wyandotte Museum.)

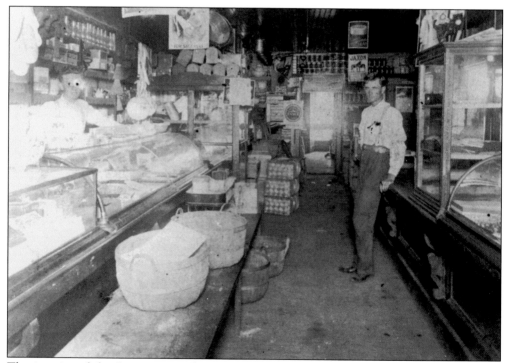

The interior of the Liptow general store displays its wares around 1890. There was a vast array of items available in the store to meet shopping needs, including cigars and tobaccos. (Wyandotte Museum.)

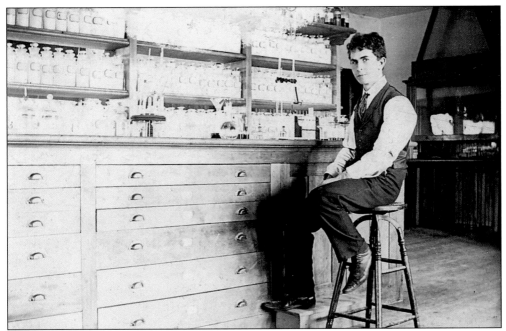

In 1863, Charles Thomas opened the first drugstore in Wyandotte. It also served as a first aid station and town communication center on the west side of Biddle Avenue between Oak and Elm Streets. Isaac Strong is seated at the C. W. Thomas Drug Store counter in this interior photograph from around 1890. (Bacon Memorial District Library.)

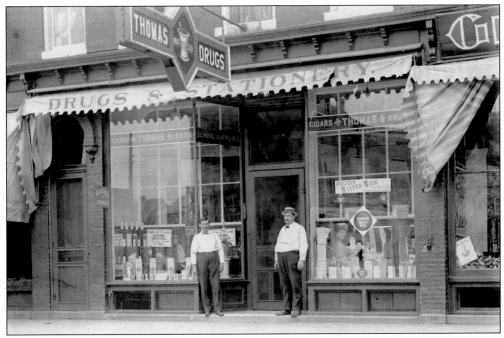

An exterior photograph shows Thomas Drugs with Charles Thomas II (left) and Judge Julius Thiede. The store was a popular location in Wyandotte and continued to meet the needs of residents until 1928 when Thomas retired. (Bacon Memorial District Library.)

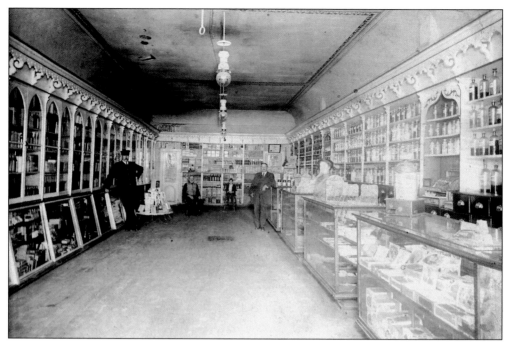

This is the drugstore two years before the store was extended to First Street. Pictured in the photograph are, from left to right, Frank Wallcott, William Brophy, Charles Thomas III, Charles Thomas II, and Grace Murphy Engfehr. (Bacon Memorial District Library.)

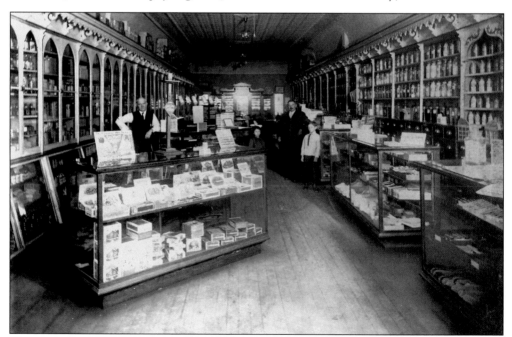

This photograph shows Thomas Drugs with members of the Thomas family, including, from left to right, unidentified, Louise Elizabeth Thomas, Charles Thomas II, and Charles Thomas III. The store offered a broad selection of cigars as seen in the front display case. The expansion of the store to First Street can also be seen. (Bacon Memorial District Library.)

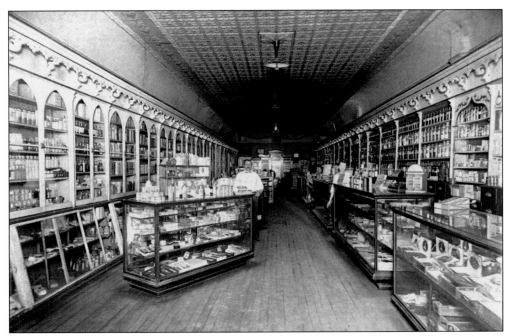

The Thomas drugstore offered a wide assortment of items to local shoppers. One entire side of the store shelving is lined with glass apothecary jars storing medicinal items and other powders. The merchants were always friendly, with time to chat about politics and the economy. (Wyandotte Museum.)

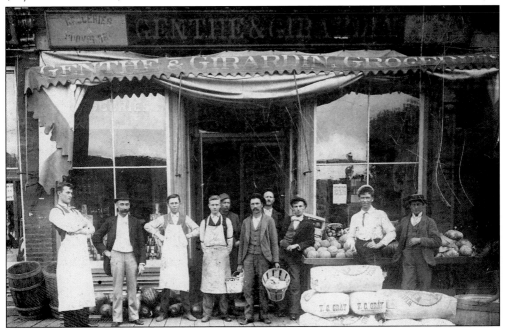

The Genthe and Girardin grocery store in 1894 was another important social gathering place to learn about community events and shop for items needed to meet a family's needs. Note the melons on the wooden sidewalk in front of the store and bags of T. C. Gray flour from the mill stacked in front of the fruit stand. (Wyandotte Museum.)

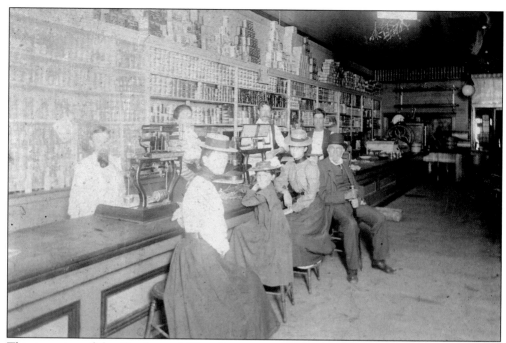

This is a view of the Genthe and Girardin grocery store's interior taken in August 1899. The store's long counters provided stools for customers while they were waiting for grocers to fill their orders. (Bacon Memorial District Library.)

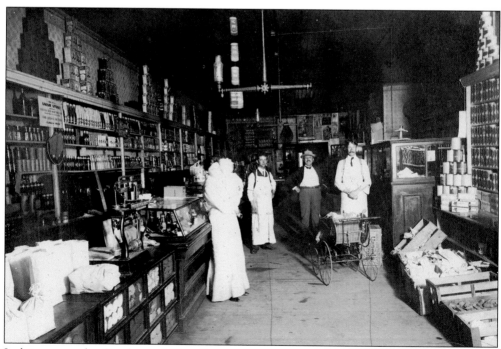

In later years, the Genthe and Girardin proprietors opened their own individual stores. This interior view of the Girardin Grocery Store was taken around 1900. (Wyandotte Museum.)

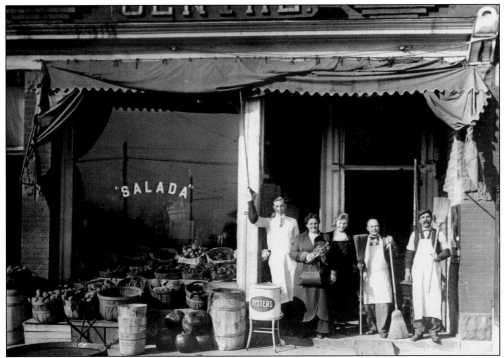

The Genthe Grocery had a broad array of vegetables and fruits as evidenced by the products displayed on the sidewalk. Salada tea must have also been a big seller in the store, as its name is displayed prominently on the glass window. (Wyandotte Museum.)

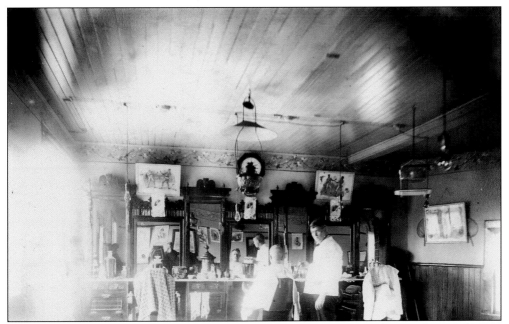

The Fury Barber Shop in 1890 offered a good haircut and clean shave along with an update on the community's latest events and rumors. This interior photograph offers a good perspective of all the various lighting fixtures and numerous ceiling items. (Bacon Memorial District Library.)

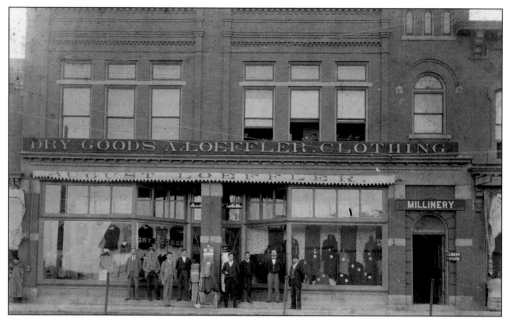

In 1894, Loeffler's Department Store offered dry goods and clothing for sale to local residents. In addition to that, the store also offered furnishings, carpets, and wallpaper. A millinery run by Mrs. Fred Johnson was located upstairs along with a dressmaking shop. It was noted that it was the largest goods emporium in the Downriver region. Note the women upstairs with one at work on the sewing machine. (Bacon Memorial District Library.)

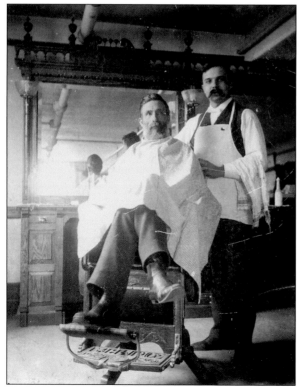

The barber and customer take time out from a haircut for a picture at the Thiede Barber Shop with barber Julius Thiede and Joseph Girardin in the barber chair around 1890. (Bacon Memorial District Library.)

George Marx opened a brewery in 1863 at the foot of Oak Street near the Detroit River. After Marx's passing in 1886, his son Frank (pictured) continued the management of the brewery. In 1896, the business was reincorporated under the name of Wyandotte Brewing Company. The name returned to Marx in 1904, and in 1910, the brewery was consolidated with the Eureka Brewing Company, which was organized and established in 1890. (Wyandotte Museum.)

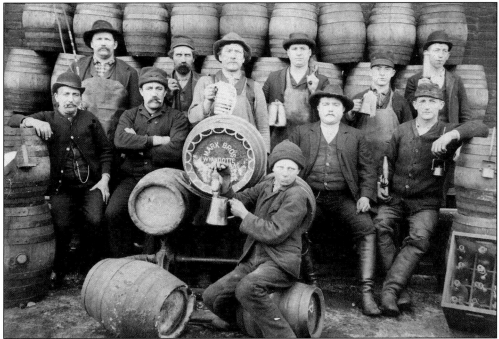

An early group of employees of the Marx Brewing Company displays the fine products contained in the kegs and bottles. It appears that several of the employees even brought their own beer mugs for this momentous photograph. (Bacon Memorial District Library.)

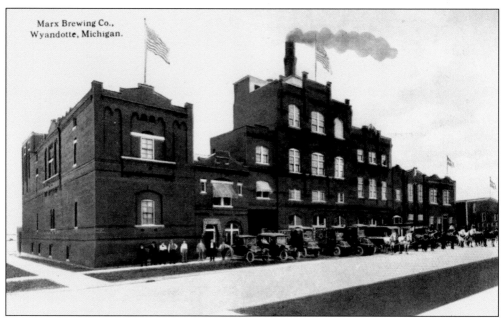

This is the Marx Brewing Company as it looked in the early part of the 20th century around 1913–1918, complete with horse-drawn wagons and vehicles. The firm was liquidated in 1936 as a result of issues associated with Prohibition. (Wyandotte Museum.)

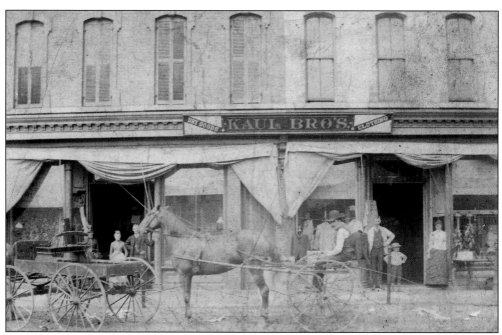

Kaul's Department Store went into business in 1880, founded by John, Henry, and William Kaul. The store as pictured in 1882 had the distinction of having the first stone sidewalk and durable hitching posts erected in front for the convenience of its customers. New show windows were installed in 1913, and in 1939, the interior and front of the store were completely rebuilt along with the installation of new fixtures. (Bacon Memorial District Library.)

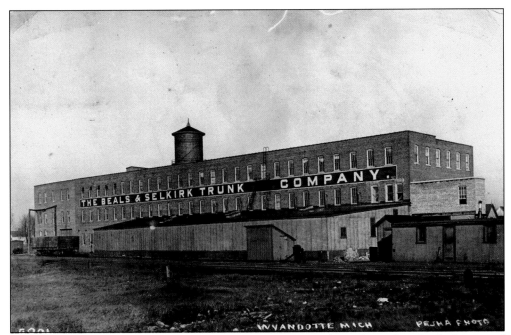

The Beals and Selkirk Trunk Company opened in 1893 and was located at Sixth Street and Superior Boulevard near the railroad tracks. The company located in Wyandotte after receiving an incentive to locate the facility there from local city government officials. (Wyandotte Museum.)

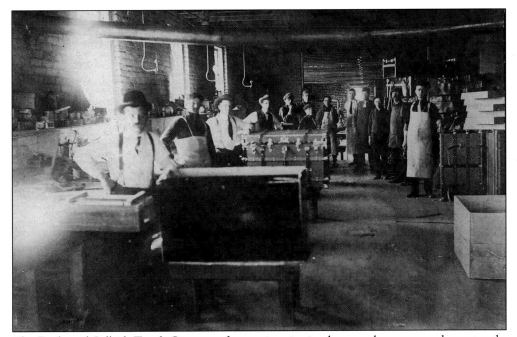

The Beals and Selkirk Trunk Company factory interior is where workmen created new trunks for the world's travelers. The workmen took great pride in the manufacturing of these trunks, which were considered trunks of high quality. (Bacon Memorial District Library.)

43

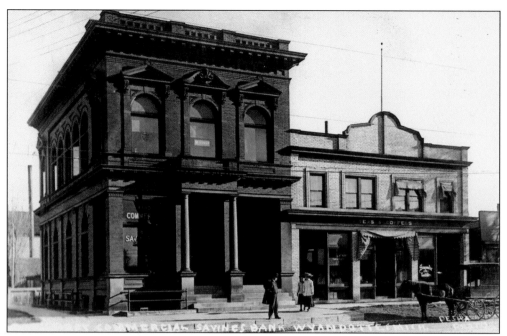

The First Commercial Bank of Wyandotte was organized in 1893 and was located at the corner of Biddle Avenue and Oak Street in downtown Wyandotte. A few years after operating, the bank reorganized and became the People's State Bank in 1929. Several of the city's dentists and doctors also had their offices in the building. (Wyandotte Museum.)

The Bowbeer Dental Office was built on the west side of Biddle Avenue between Chestnut and Oak Streets in the late 1890s. Dr. Norman Bowbeer was a pioneer in the belief that the care of the first teeth of children was important, including the use of gold fillings. His theory was later approved by the National Dental Association. (Bacon Memorial District Library.)

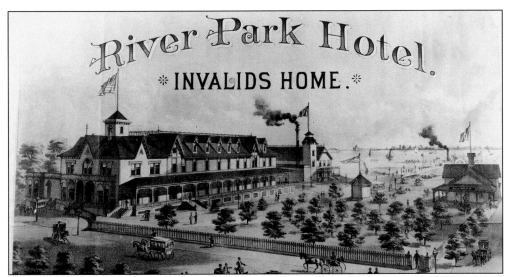

Wyandotte became nationally renowned for its white sulphur springs in the 1880s. The River Park Hotel advertised the true benefits of the springs with such ads as "pleasure and health resort, finest water place and invalids' home in the union. A hotel, not a hospital. Steam heated, hot and cold water, gas etc. Open the year round. These waters and baths are certain cure for paralysis, gout, rheumatism, nervous disorders, liver and kidney complaint." The hotel offered accommodations for 500 guests. Visitors came from all over the country to try the Russian, sitz, and electric baths. Many travelers arrived by side-wheel steamers to enjoy the hotel's amenities. (Bacon Memorial District Library.)

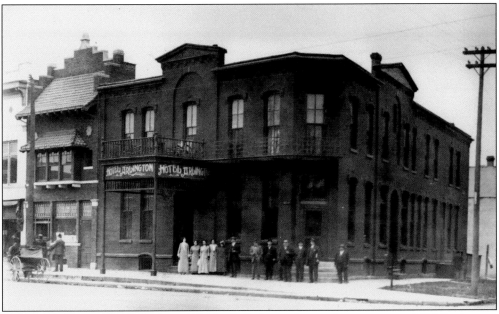

The Arlington Hotel was built in 1884 by P. Debo at the southwest corner of Biddle Avenue and Oak Street in downtown Wyandotte. It served fine food and excellent liquor and provided lavish furnishings. It served over the years as the place for gathering politicians. It continued in business for 35 years until closing in 1919. It later became Armstrong's Men's Clothing, and the original building still stands today. (Bacon Memorial District Library.)

The Cahalan Drug Store was originally established as a general merchandising store in 1879 by Richard and John C. Cahalan. The store changed to a drugstore in 1880 when John graduated from McGill University and returned to Wyandotte. In 1885, the store was moved to the corner of Biddle Avenue and Elm Street, and in 1897, it moved to a new location on the west side of Biddle Avenue between Oak Street and Elm Street. (Bacon Memorial District Library.)

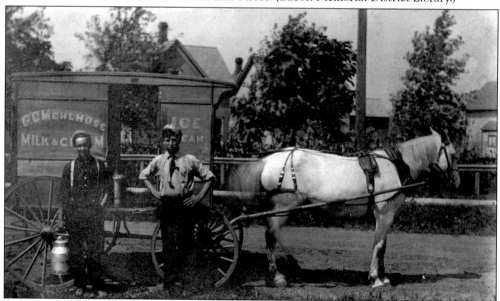

Hugo Mehlhose opened his business as a merchant in ice cream and candy. He claimed that he had the distinction of being the first merchant to serve ice cream sodas. After a while, Mehlhose decided to place a greater emphasis on meats and groceries, and in 1888, his nephew Gustave Mehlhose began the operations of an ice cream factory at Fourth and Oak Streets. In the early days, it was the only place in town where a person could purchase ice cream in a large quantity. (Bacon Memorial District Library.)

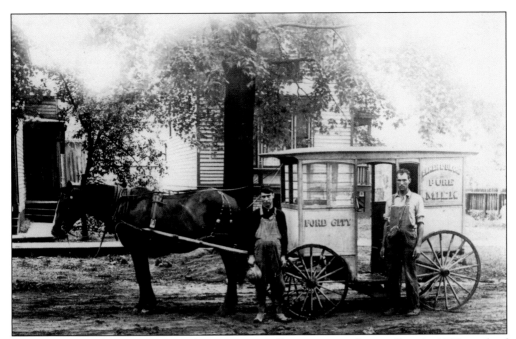

Ford City, located in Ecorse Township, was originally incorporated as a village in 1902 north of the city of Wyandotte. It was annexed to Wyandotte and became part of the city in 1922. Prior to the annexation, milkmen Lloyd Jarvis and Columbus LeBlanc made their early-morning daily rounds delivering milk to the local residents. (Bacon Memorial District Library.)

Gettleman's Bazaar 5 and 10¢ store was located on the west side of Biddle Avenue. There are very few existing records detailing the history of this business. It appears that shop owners left no space uncovered when having a sale in their business as evidenced by the huge signs in the windows advertising the sale. (Bacon Memorial District Library.)

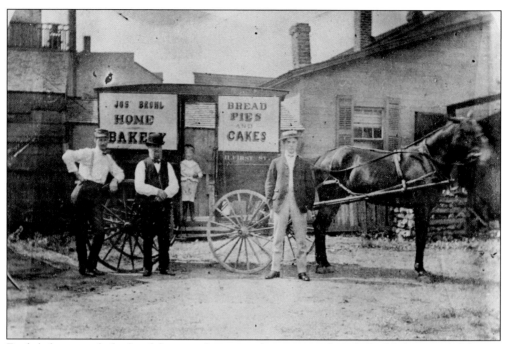

Fresh bakery goods for breakfast are always a welcome treat. Joseph Brohl dispensed delicious cakes, cookies, bread, and pies to families in the city. Brohl's bakeries started in 1865 and continued in business until the 1930s. (Bacon Memorial District Library.)

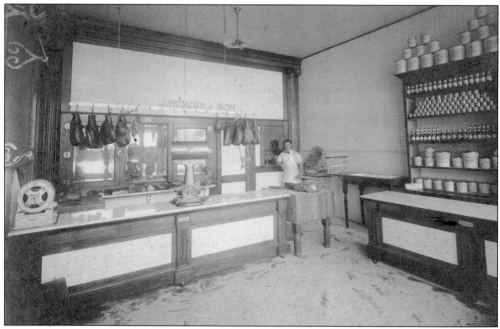

Bigler's Meat Market offered a broad selection of meats to its customers. Note the sawdust on the floor and the elaborate cash register in the middle background of photograph. Meat lies on the butcher block ready for cutting and wrapping. The Bigler name was well known in Wyandotte for fine quality meats. (Wyandotte Museum.)

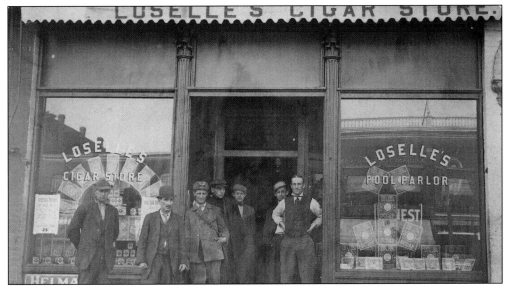

Loselle's Cigar Store offered the gentlemen of the day fine cigars and the chance to play a game of pool when visiting the store to purchase their cigars. The business started in 1889 and closed in 1923. As noted in a local newspaper, it was a familiar hangout for the sporting fraternity. A person could hear the latest sports score and discuss sports topics of the day. (Wyandotte Museum.)

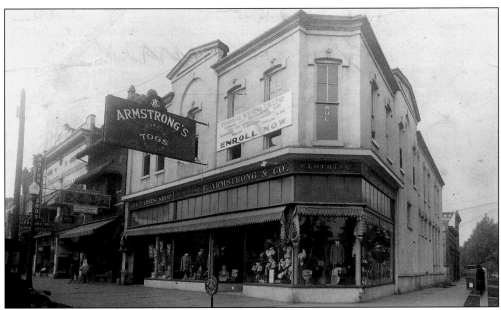

Armstrong's Men's Clothing opened in the former Arlington Hotel building at the corner of Oak Street and Biddle Avenue in 1920. Frank Armstrong came to Wyandotte in 1899 after working in clothing stores in the city of Detroit. A ladies' shop next door was operated by Mrs. Armstrong in 1929 and offered ladies' apparel, sundry accessories, and jewelry. (Wyandotte Museum.)

In 1915, Fred Torango Meats was located on Biddle Avenue between Sullivan Street and Davis Street. Torango's residence was located immediately next to his business. He is seen standing in front of his business wearing a white apron with his wife, Fannie, and their children standing in front of their home. (Wyandotte Museum.)

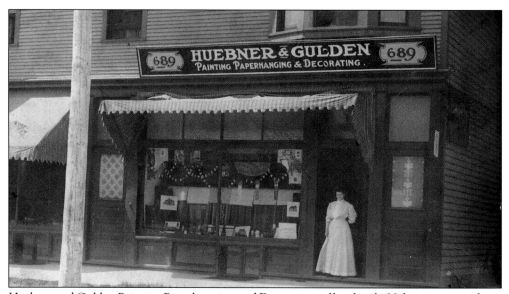

Huebner and Gulden Painting Paperhanging and Decorating offered early-20th-century residents a fine selection of wallpapers and paperhangings and a large choice of colors for painting the parlor, kitchen, bedroom, or child's room. Various wallpapers are displayed in the windows along with home renderings colored with the various paints to give the home owners an idea of how beautiful their residence would look with their products. (Wyandotte Museum.)

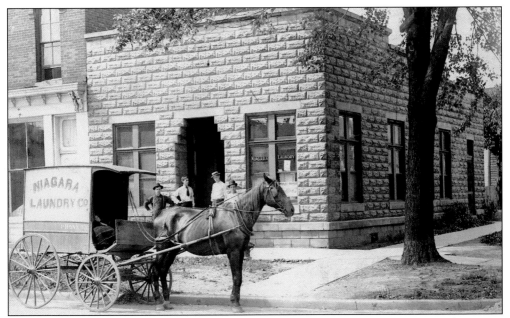

Oscar Stieler, proprietor of the Niagara Laundry Company, operated his business at the corner of First and Oak Streets. A laundry advertisement offers to clean soiled linen and guarantees the owners' satisfaction of a clean domestic or gloss finish on all of their cleaning. Local residents would have their laundry picked up and delivered by a horse and wagon on a regular basis. (Wyandotte Museum.)

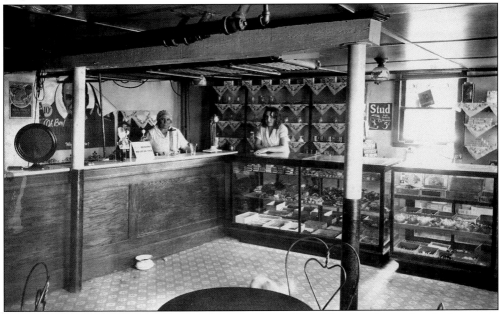

Sweetshops were popular spots in the 1920s. The Laritz Sweet Shop was located in the basement of the Katherine Laritz home at Thirteenth Street and Eureka Avenue. The sign on the counter promotes delicious ice cream sodas, and the counters on the right are full of wonderful candies and candy bars. The shop also offered ice cream parlor tables and chairs to the patrons so they could take their time enjoying the delicious creations. (Wyandotte Museum.)

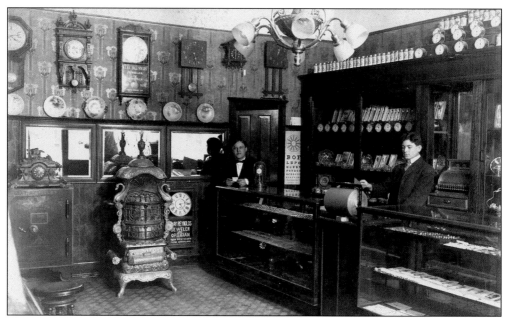

This optical and jewelry business was located next to the Majestic Theatre in downtown Wyandotte. It is a very unusual store, displaying wares including optical items and jewelry. In addition to those items, the store offered clocks, special spoons, and cut glass. It appears that alarm clocks were big sellers too, as they are displayed on shelves in multiples in the large glass back case along the wall. (Wyandotte Museum.)

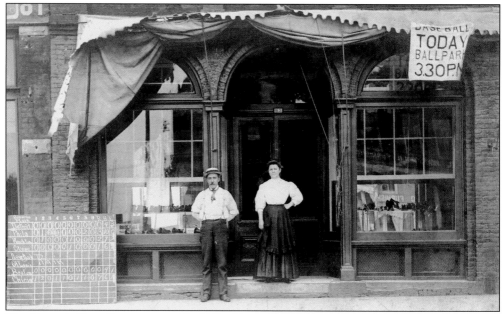

The Hoersch Shoe Store operated by Tillie Hoersch not only sold shoes but also kept the local citizens informed of the latest scores from the national American baseball teams on a daily basis. The windows displayed the latest styles of women's shoes (see right window) and men's shoes (see left window). As displayed in the banner above the window, there was a local baseball game in the park at 3:30 p.m. that day. (Wyandotte Museum.)

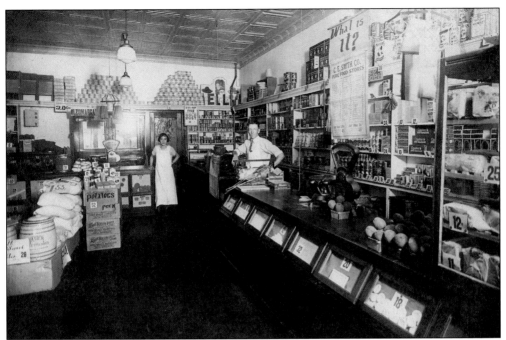

Located on Biddle Avenue, the C. F. Smith Company Pure Food Store offered many quality items for the grocery shopper. A large pickle crock sits on a shelf on the left of the picture, and fruit sold for 10¢ and 20¢ per can. Court House Tea sold for 35¢ and Court House coffee sold for 45¢. Mother's Brand Crushed Oats and Kellogg's Krumbles are well stocked on the top shelf at right. (Wyandotte Museum.)

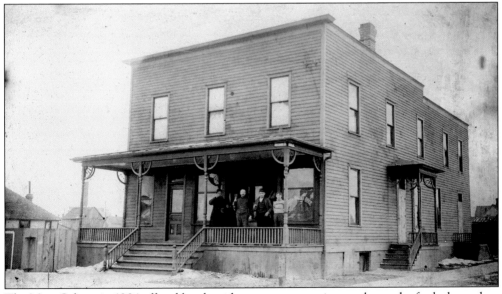

The Marx Saloon in 1904 offered local residents an opportunity to relax and refresh themselves with a shot of whiskey and a good, cold beer. Located at the corner of Orchard Street and Sixth Street, the patrons took time out to gather on the porch for a quick photograph The window on the porch has stenciling that promotes Frank Marx's Beer. (Wyandotte Museum.)

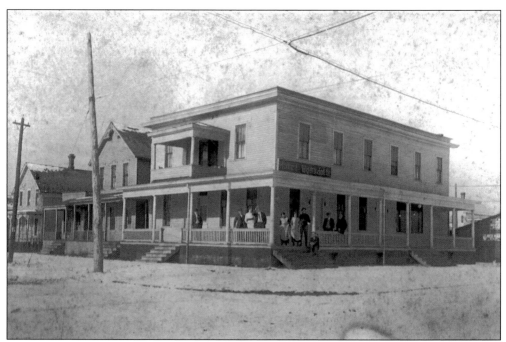

The Wyandotte Hotel was located at the corner of Elm Street and First Street. Patrons and hotel staff can be seen standing on the wraparound porch posing for the photographer. In 1914, hotel rates were an astounding $1.50 per day. (Wyandotte Museum.)

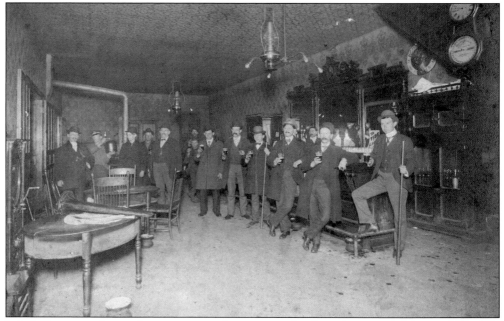

It is 8:48 p.m., and several musicians on their way to play for a dance stopped in at Theodore Megges' Saloon for a cool drink and a visit with local patrons. This saloon had some rather interesting light fixtures and a number of spittoons scattered around the tables and at the bar. The saloon must also have had pool tables in another area as some of the guests are holding pool cues. (Wyandotte Museum.)

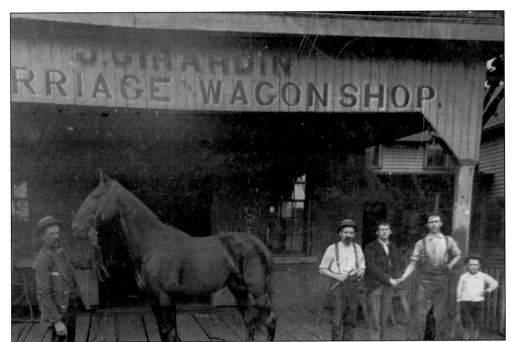

The Girardin Carriage and Wagon Shop was a small business that built fine carriages to order for Wyandotte residents and customers outside the city. Posing for the photographer are, from left to right, Aaron Strong, Lee Miller, Alfred Kreger, Warren Girardin, and an unidentified child. Iron wheelbarrows and blacksmithing were also industries in this shop. (Wyandotte Museum.)

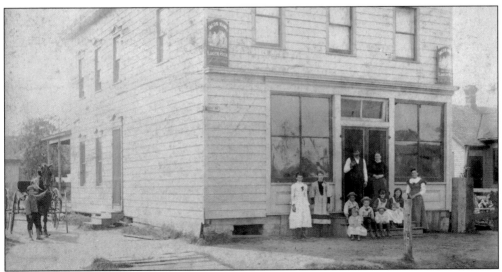

Adolph Shultz's Saloon, located at Third Street and Pine Street, offered local residents another location to socialize with neighbors and refresh themselves with a drink. The sign over the corner of the building advertises Jacob Mann's Lager Beer. Whenever a photographer was present, neighborhood children seemed to congregate to hopefully be included in the photograph. (Wyandotte Museum.)

The McGlaughlin Block Building, formerly the Quinn Hotel in 1875, was located at the corner of Orange Street and Biddle Avenue and purchased in 1922 by Dr. J. S. McGlaughlin. McGlaughlin remodeled the entire building. The building included a hotel, haberdashery, and pharmacy, with an office for McGlaughlin. The pharmacy sold film, stationery, cigars, patent medicines, toilet articles, and candy. (Wyandotte Museum.)

The John J. Kreger Farming Implements Store was located on the southeast corner of Eureka Avenue and Fifth Street. The store was the headquarters for farming implements, buggies, carriages, wagons, bicycles, and farm and garden seeds that were sure to grow. An early advertisement also indicates that the wood yard was constantly stocked with hard and soft wood. The store promoted the fact that it made repairs of all kinds. (Wyandotte Museum.)

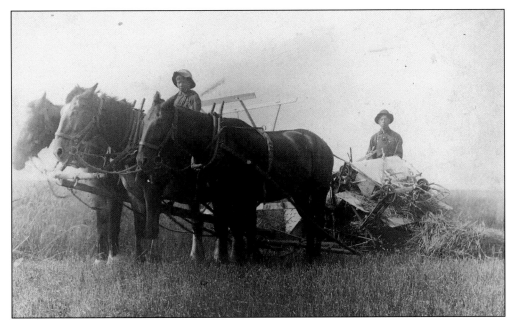

Farming was not a simple life. Farmers in 1900 worked long and hard days. Wyandotte was fortunate to have many new businesses developing as well as expanding industries, but there were local residents who also farmed the land within the boundaries of the city. This farmer and young boy in the field with a three-horse team are cutting their crop and working the land to make a comfortable living. (Bacon Memorial District Library.)

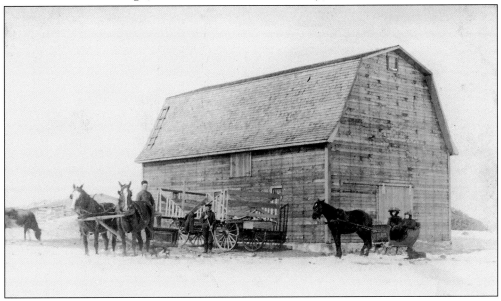

There was a need for John J. Kreger's farm implements business in Wyandotte as people continued to farm and a broken plow or threshing machine needed repair. The McPherson farm was located west of Wyandotte off Eureka Road. Many of these residents living on the periphery of the city's boundaries came to the city to conduct business and socialize. These farmers appear to be cleaning a few things up around the barn, and the ladies are out in the sleigh wearing their warmest coats. (Bacon Memorial District Library.)

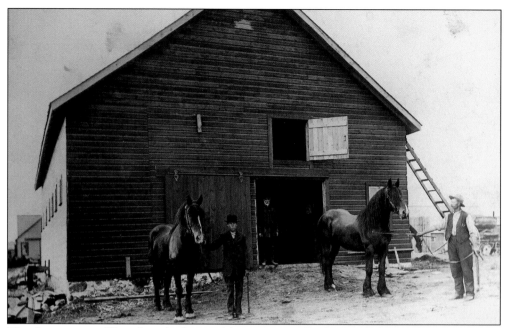

This farm in west Wyandotte had several horses to get the farmwork done. The farmers were proud of these animals and provided a well-constructed barn to protect them from the elements. It also appears that some roofing work was being done before the winter snows arrived in the late fall. Note that the one gentleman holding the horse is also probably wearing his best suit for the photograph. (Bacon Memorial District Library.)

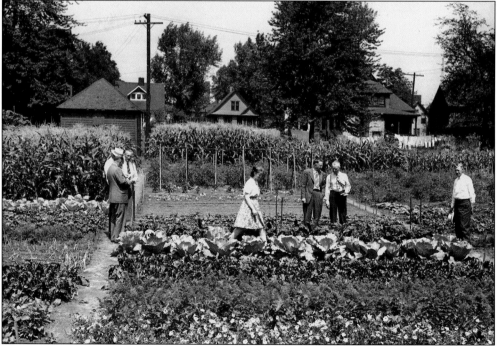

In 1945, local residents grew victory gardens in the city as part of the war effort during World War II. These citizens are admiring the success of their gardens. (Bacon Memorial District Library.)

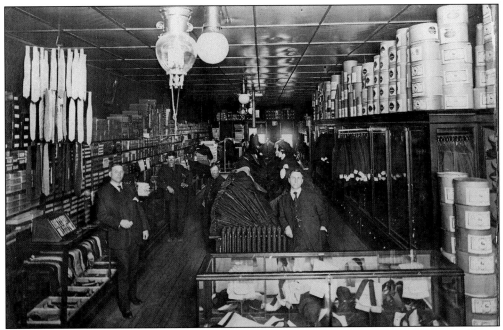

Henry and Conrad Roehrig owned and operated Roehrig Brothers from 1910 to 1939, offering clothing, hats, and gentlemen's furnishings. Ties hang from the ceiling and are also displayed in the glass case. The latest selection of men's hats appears in the front case, and the store is well stocked with men's shirts and suits. (Wyandotte Museum.)

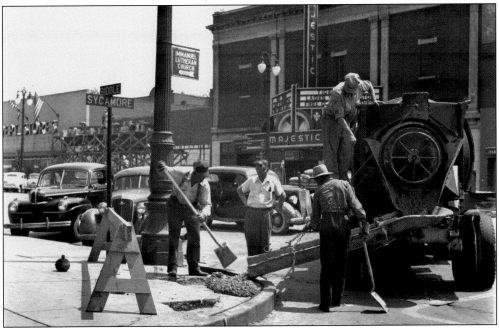

The Majestic Theatre was equipped and operated by the Wyandotte Theatres Corporation. Seating capacity was over 1,000 with a fully equipped stage and organ. Management also boasted of having the most complete projection booth of any state. Features included photoplays that changed daily and vaudeville acts. Admission was 10¢ and 15¢. (Wyandotte Museum.)

The Marx Theatre was erected in 1910 and located at the corner of Biddle Avenue and Sycamore Street. The theater was located on one floor and offered stage plays and moving pictures in later years. By 1931, the building was razed to make way for more modern buildings. (Wyandotte Museum.)

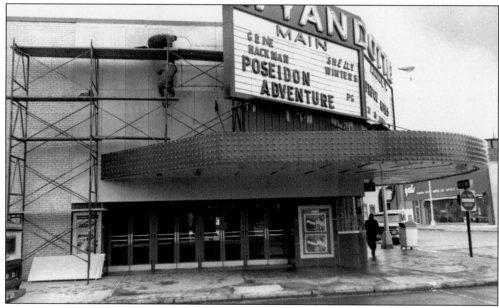

The Wyandotte Theater, built in 1939 at First Street and Elm Street, was the first theater in the United States to be constructed with two auditoriums under one roof. It could run double features and sell them as single features, with patrons viewing only one of two pictures at a given time. The theater had an interior Native American theme throughout the building. The building has undergone several renovations in recent years, and its future is uncertain. (Wyandotte Museum.)

Three

DOWNTOWN

As the major industries in the community continued to grow and small businessmen brought new businesses to this prospering community, the downtown business district continued to grow on a steady basis. A promotional booklet from the early years encouraged future growth by inviting, "come all ye who are looking for a home, employment or investment. To see Wyandotte, know her people, and learn of her advantages from every standpoint and individual preference is to decide to stay here. Welcome all, the latch string is out for you." With the constant growth came the demand for fire protection in the city, more substantial roads, cement sidewalks, and new home construction. The downtown business district was alive and well and ready to accept any business person willing to make a financial investment in a new business. A new business, however, also demanded a personal commitment to long hours and the ability to take on new challenges and brave continuing economic changes.

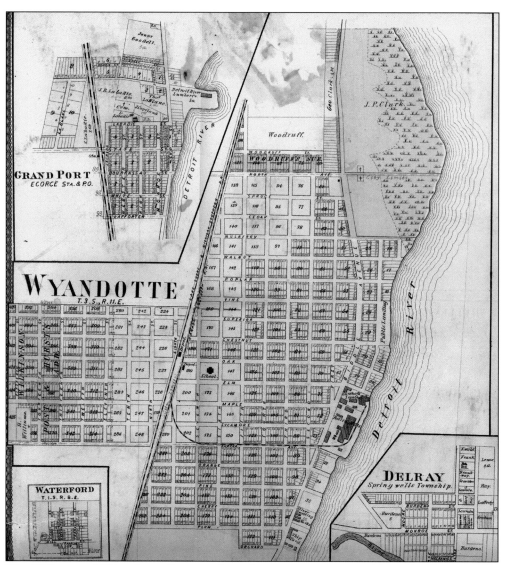

The 1876 map of Wyandotte illustrates how the city was growing. Along the Detroit River are the shipyards, silver smelting, rolling mills, Eureka Iron facilities, public landing area for excursion and other boats, public school, train depot, and downtown business district on Biddle Avenue. In addition, the city map shows all the property upon which the residents built their homes. To the west of the city, the Canadian Southern Railroad and the Lake Shore and Michigan Southern Railroad ran train lines north to Detroit and south toward Toledo. By the early 1900s, it cost 65¢ one way to reach Detroit by rail. Local excursions from Wyandotte went to Hog Island, now called Belle Isle, a beautiful city park at that time in Detroit. The original name of Hog Island came derived from the existence of hogs roaming the island killing off the many rattlesnakes that infested it. An early account of Wyandotte speaks of visitors to Wyandotte being great admirers of the beautiful shade trees found on all the older streets. The selection of trees included black walnut, hickory, white wood, and oak in several varieties. From its beginning, Wyandotte has been a city of homes. Wyandotte's wide streets have undoubtedly been a great source of fire protection as the city has been noted throughout its history as never having had a conflagration. (Wyandotte Museum.)

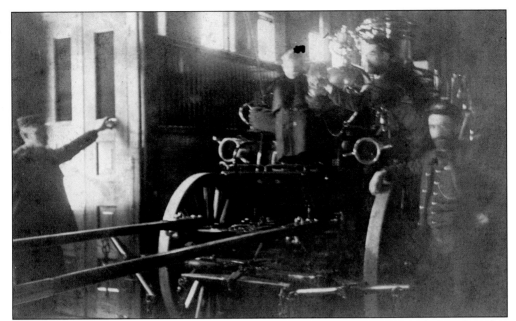

A volunteer fire department was organized in 1870, and by 1876, the city purchased its first fire engine. This is an early example of one of the first pieces of fire equipment owned by the Wyandotte Fire Department. What a thrill for a young person to be able to have a picture taken on such an important piece of equipment that was drawn by horses. The brass couplings on the hoses were always highly polished. (Bacon Memorial District Library.)

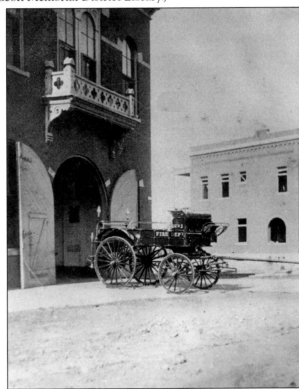

A view of the fire hose wagon does not show the horses but shows some of the city hall building and the location of the fire department on the first floor. (Bacon Memorial District Library.)

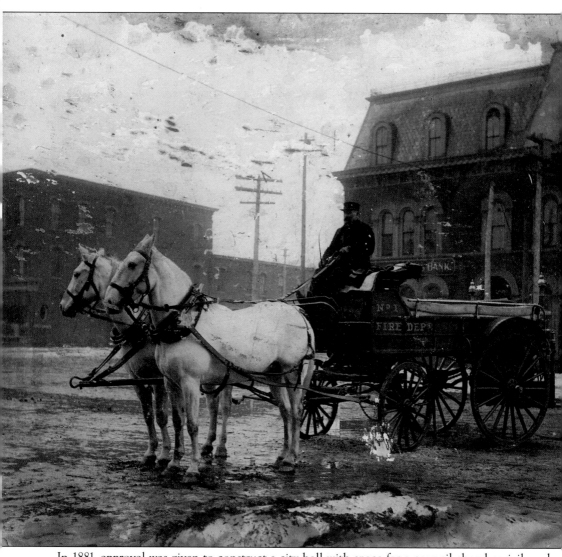

In 1881, approval was given to construct a city hall with space for a council chamber, jail, and engine house for the fire department at the cost of $8,769 with the statement that "the city has a good cheap building and no reason to complain except in the delay attending its completion." The building was constructed of red brick with stone trimmings and stood two stories high. Wyandotte was proud of its hose cart equipment as seen in this photograph taken on Biddle Avenue around 1890. At the sound of an alarm, the wide, round doors opened automatically and a device released stall doors. The horses ran around the side of the engine to their places beside the wagon tongue and stepped into position over their harness on the floor. From above the engine a mechanism lowered the halter automatically. Firemen quickly fastened a buckle on the front and they were off racing down the street to respond to the alarm. (Bacon Memorial District Library.)

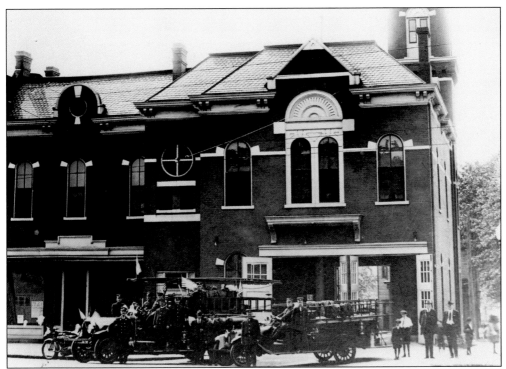

This view shows the Wyandotte City Hall and Fire Department in Wyandotte and provides a view of the building. (Wyandotte Museum.)

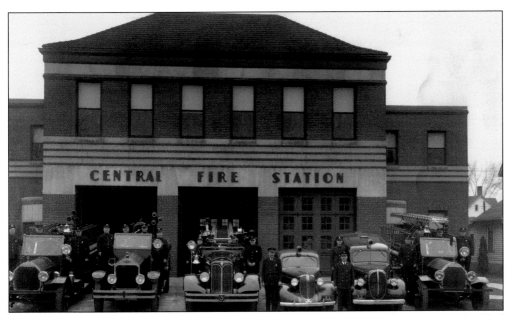

During the mid-20th century, the Central Fire Department continued to grow and added equipment to its larger and more modern building. Here it is proudly displayed along with the men who fought the fires when summoned for assistance. (Wyandotte Museum.)

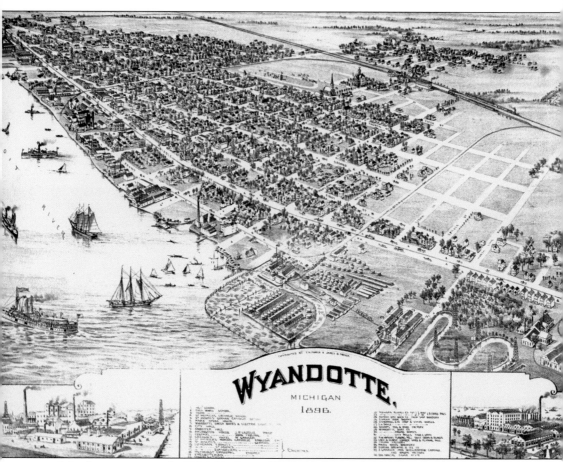

A bird's-eye view map by T. M. Fowler and James B. Moyer shows the city of Wyandotte in 1896. Artists would travel the country sketching bird's-eye views of a city and then offering them for sale to local residents. They attained such a perspective from a hot air balloon, a high building, or even sitting on a water tower to sketch. These views are quite accurate and generally reflect good detail even down to the horse and wagons and streetcars. This map provides a layout of the city as well as a view of the locations of industry along the Detroit River and gives the viewer an idea of the number of ships that sailed along the waters for both commerce and recreation. The legend in the center of the map provides a listing of some of the industries, churches, schools, and smaller businesses in existence at that time. They provide historians with an excellent concept of the state of the city during that historical period. (Wyandotte Museum.)

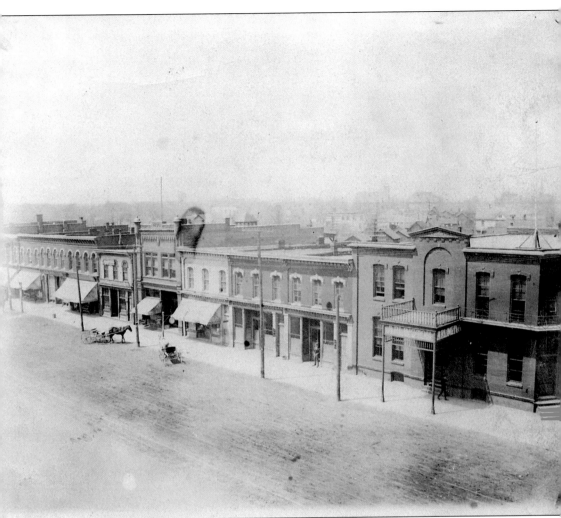

A very early downtown Wyandotte view shows the western side of Biddle Avenue. The road was still dirt and unpaved. In later years, it would become paved with brick. Patrons frequenting the businesses would drive their wagons or buggies to the front of the businesses and tie their horses to a pole or available hitching post along the road. Winter's deep snow and spring rain would form large ruts in the dirt road, making a trip to the store a difficult experience. The Arlington Hotel, constructed in 1884 at the corner of Oak Street and Biddle Avenue, is at the immediate right in the photograph. Travelers who wanted distinctive hotel service could book a room for the night or the week. The guest list itself was of special interest in the community and was posted weekly in the local newspaper under the heading of new arrivals at the Arlington. (Bacon Memorial District Library.)

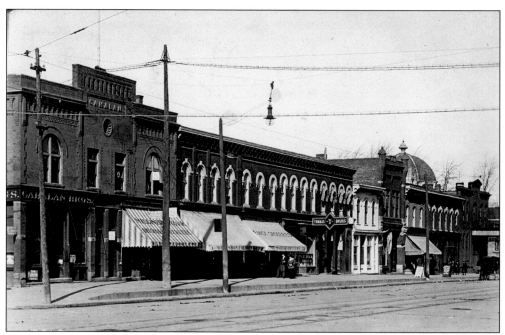

The Cahalan Brothers building, Thomas Drugs, a millinery store, and a fancy grocery store are all seen here in this postcard photograph taken in the Wyandotte downtown business district around 1910 along Biddle Avenue. (Bacon Memorial District Library.)

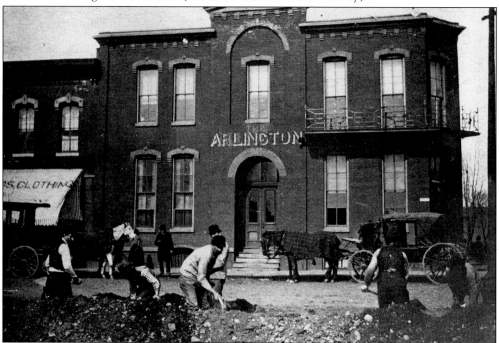

At the corner of Biddle Avenue and Oak Street, it appears that workmen are digging an area for the laying of streetcar tracks. The streetcar was a more convenient mode of transportation to Detroit. The service started in May 1892 with a fare of 15¢ one way and 25¢ round-trip. (Bacon Memorial District Library.)

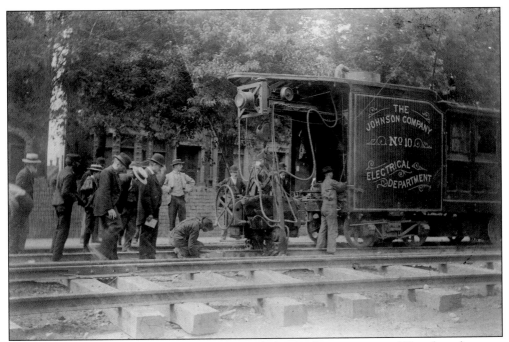

The Johnson Company is shown laying the track for the first streetcar in Wyandotte between Superior Boulevard and Chestnut Street. It appears that the supervisors are checking on the progress of the workmen and rails along with a few interested citizens also observing the progress of the project. (Bacon Memorial District Library.)

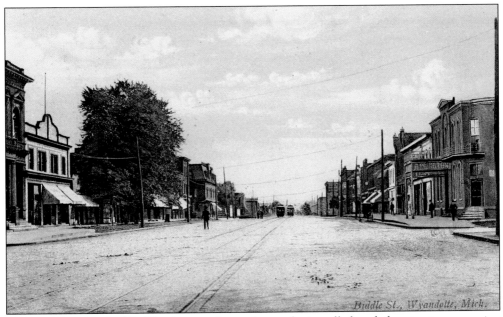

This early postcard of Biddle Avenue shows the tracks installed and the streetcars running through the city. Some people chose to still use a horse and buggy or walk to their destinations. Shortly after World War I, the automobile provided an easier mode of transportation, and by 1932, the streetcar service ended. (Bacon Memorial District Library.)

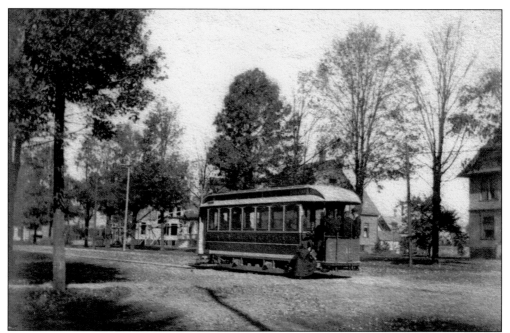

A lady boards the streetcar maybe to visit a friend or to do some shopping. This mode of transportation offered a convenient way to reach destinations in downtown Wyandotte. It appears that the men liked to stand at the rear of the car to let the women and children take the seats inside. (Wyandotte Museum.)

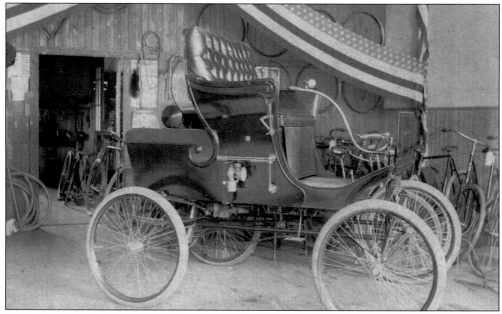

With the arrival of the automobile, some individuals decided to build their own car. Dwight Baxter built this car in a bicycle shop in the building behind the Brohl Bakery. He must have been proud of his accomplishment, as there is a red, white, and blue bunting hanging from the ceiling of the building. It might have also been used to promote his bicycle business. (Wyandotte Museum.)

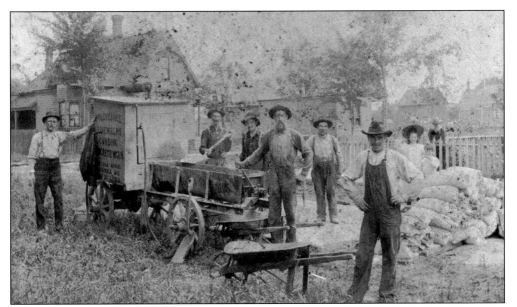

As the city continued to grow, it was apparent that the plank sidewalks and dirt roads were no longer adequate. In 1887, the city experimented with cinder walks made from coarse cinders spread with ashes from the rolling mill and top-dressed with sawdust from the shipyard and stave mills. In 1888, a stone sidewalk was installed in front of Kaul's Department Store. Cement sidewalks were installed by 1899, and the old plank walkways disappeared. (Wyandotte Museum.)

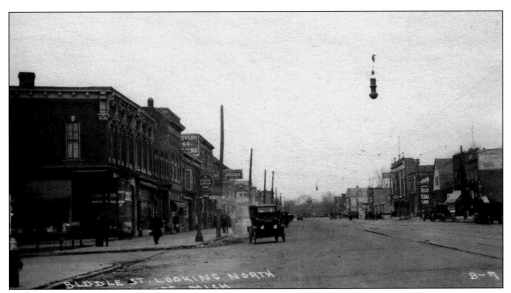

Cement pavement was finally laid in 1914, transforming dirt roads into paved surfaces. Areas that were first paved include Van Alstyne Boulevard from Elm Street to Eureka Avenue, Poplar Street, Chestnut Street, and Eureka Avenue. Gone were the horse and buggy when the automobile made its appearance in the community. It was now a pleasure to go motoring throughout the city without the dust and ruts of the dirt roads. The publisher of this photograph continues to call Biddle Avenue by the incorrect name of Biddle Street. This is a view looking north on Biddle Avenue. (Wyandotte Museum.)

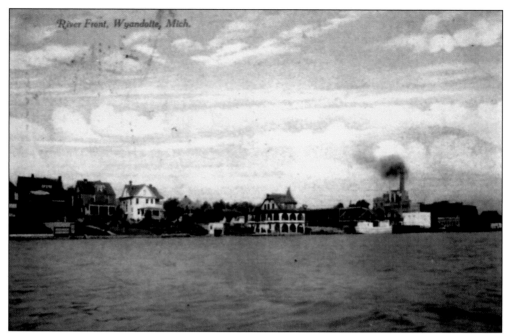

Along with the bustle of downtown business and industry, Van Alstyne Boulevard offered grand homes along the waterfront adjacent to the business district. This is a view looking west from the Detroit River showing the homes on the left, the American Legion building in the center, and the Municipal Light Plant on the right with the tall smokestack. (Wyandotte Museum.)

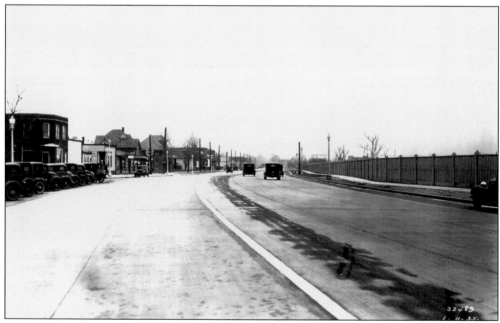

A view of Biddle Avenue looking north shows a widened 120-foot right-of-way containing an 80-foot concrete pavement. Note the permanent white center traffic line installed, sidewalks constructed, and lighting facilities relocated. The tall fence on the right side enclosed the Wyandotte Chemicals property. (Wyandotte Museum.)

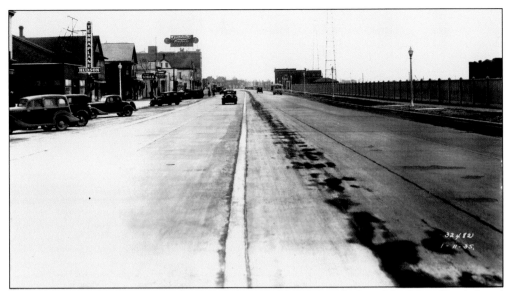

This is a view of Biddle Avenue/Jefferson Avenue looking north from Northline Road. Local residents preferred the Biddle Avenue name, which continues to the present day. The business district on the left was formally part of the village of Ford and was annexed to Wyandotte in 1922. (Wyandotte Museum.)

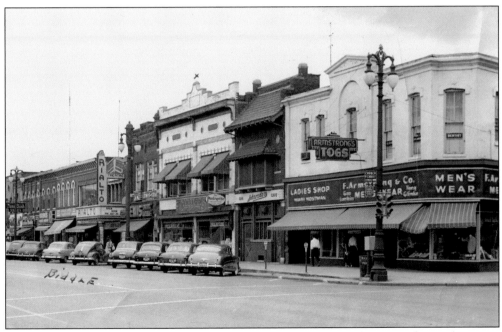

This is a view of the west side of Biddle Avenue from Oak Street to Elm Street during the 1940s, showing businesses including Armstrong's Togs, Schroeder's Bar and Cafe, the Rialto Theatre, and others. Parking meters have been installed, and the street is lined with automobiles. (Wyandotte Museum.)

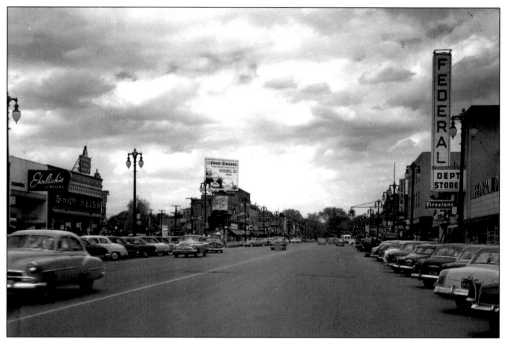

The heart of downtown Wyandotte is bustling with business during the mid-1900s, including Federal's Department Store, Firestone Automotive, Ehrlich's Jewelers, and Neisner's Five and Dime. Also included are Cecilia Melody's, the Rialto Theatre, and many more. (Wyandotte Museum.)

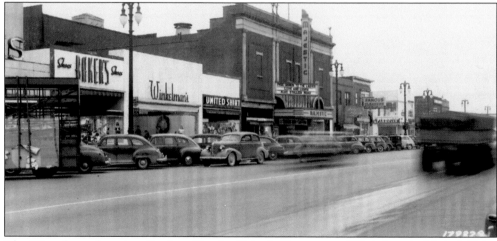

The Wyandotte shopping district offered a Baker's Shoes store, Winkelman's, United Shirt, Lady Madison Shop, and Grinnells. When one tired of shopping, one could take in a movie at the Majestic Theatre. The theater also offered free dishes to the ladies to build that special collection of china. Sears also had a major presence in downtown Wyandotte from the 1940s until it closed in 1977 when a new store was opened in Lincoln Park. (Wyandotte Museum.)

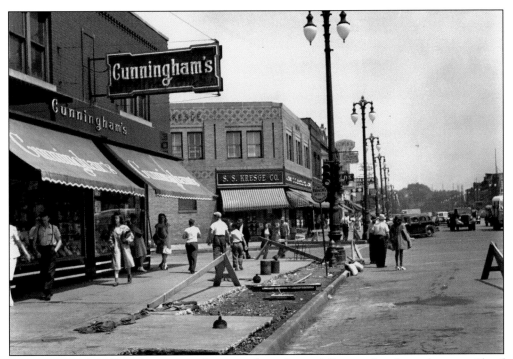

A necessary sidewalk replacement is being made in front of Cunningham's on the west side of Biddle Avenue just south of Sycamore Street in June 1946. Note the elaborate streetlights along the curb area of the business district. (Wyandotte Museum.)

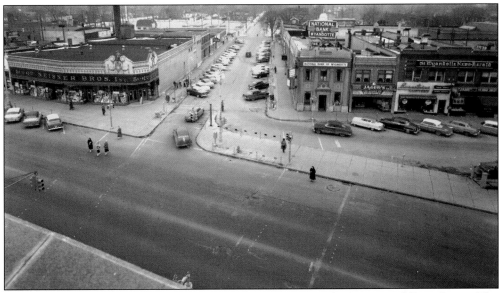

A bird's-eye view shows the juncture of Biddle Avenue, Maple Street, and First Street. The Neisner's Five and Dime was a beautiful building and quite extensive for a five-and-dime store. Note the rather extensive glass window display area filled with merchandise. The National Bank of Wyandotte and the *Wyandotte News Herald* all had very prominent locations in the city. Jager's Appliances and Hardware and Burnstein's Clothes had excellent locations to conduct business in a bustling city. (Wyandotte Museum.)

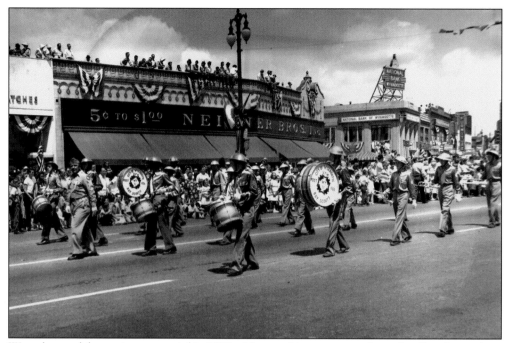

Wyandotte celebrates its centennial in 1954 with one of its many grand parades. Parade watchers were even allowed to view the parade from the rooftop of Neisner's Five and Dime as a result of the large number of people attending the event. (Wyandotte Museum.)

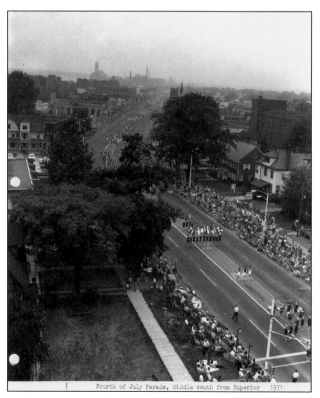

Fourth of July Parade, Biddle south from Superior 1971·

The city of Wyandotte has celebrated the Fourth of July with an annual parade for many years. This bird's-eye view of the parade marching down Biddle Avenue heading south toward the downtown business district provides the observer with an idea of the immensity of Biddle Avenue and the number of people who lined the street. Large numbers of individuals from outside the city would also attend this grand event, which also offered local residents an opportunity to see old friends and visit with family members in town for the holiday. (Wyandotte Museum.)

Four

ARCHITECTURE AND HISTORIC HOMES

Many of the first houses in the village of Wyandotte were constructed by Eureka Iron Works for its employees and were cottages with minimal architectural detailing. These structures were generally one-floor dwellings. Following the construction of these homes, company row houses or rolling mill houses were constructed and reflected a very plain structure with some architectural detailing such as Greek Revival accents or dentil molding. During the late Victorian period, larger homes with rich embellishments were built. The majority of these larger homes were constructed along Biddle Avenue and along the Detroit River on Van Alstyne Boulevard with some west to the railroad tracks. The following pages provide a sampling of the exteriors and interiors of some of the numerous architectural gems built in the community.

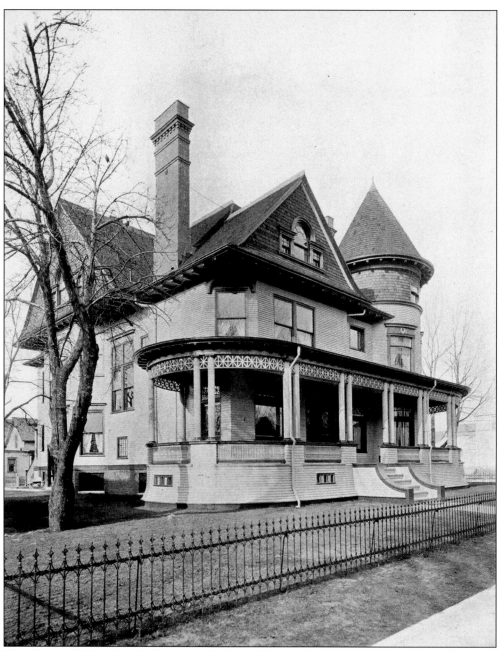

The George P. MacNichol Home was built in 1896 on Biddle Avenue by Edward Ford and presented as a wedding gift to his daughter Laura and her husband, George P. MacNichol, M.D. The Queen Anne–style architecture features a wraparound porch and turret with conical roof and projecting gables. The original fence as pictured in the photograph has also been reinstalled across the front of the home. The structure was designed by the noted architectural firm of Malcomson and Higginbotham in Detroit and is listed on the National Register of Historic Places. It is owned by the City of Wyandotte and serves as the Wyandotte Museum. (Wyandotte Museum.)

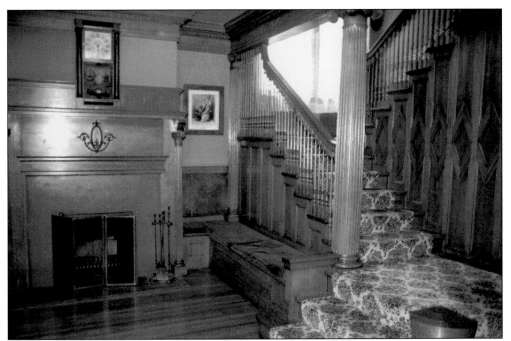

The reception area of the George P. MacNichol Home is warm and inviting with Corinthian columns and golden oak woodwork. Dentil molding surrounds the perimeter of the room with the grand oak staircase carpeted in the late-Victorian style. (Wyandotte Museum.)

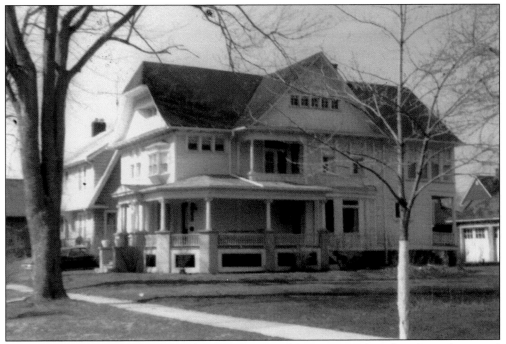

The Gartner home, which is located at 234 Vinewood Street, is attributed to the architectural firm of Malcomson and Higginbotham and was built around 1893. This home is a fine example of Queen Anne–Victorian architecture. (Wyandotte Museum.)

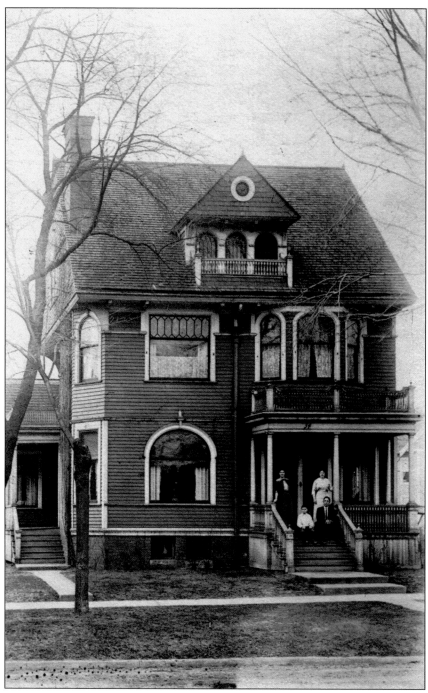

The Smith Home was originally located at 80 Vinewood Street and was built by a Mr. Babcock, a local banker, for himself and his family in 1893. Babcock died in 1912, and the home was sold to Robert William Smith and his family of six. Smith was very involved in local civic affairs and served several terms on the city council. The Smith Home shows many architectural characteristics of the Queen Anne style popular in the late 19th century. In recent years, the home was moved to a new location on Biddle Avenue. (Wyandotte Museum.)

The James Campbell home was built at 144 Chestnut Street during the late 19th century. This home offered spaciousness for a growing family. Campbell served as mayor in 1877 and as justice of the peace in 1880. Note that the road in front of the home is not paved and there is a small platform near the street to assist passengers into their carriages. (Wyandotte Museum.)

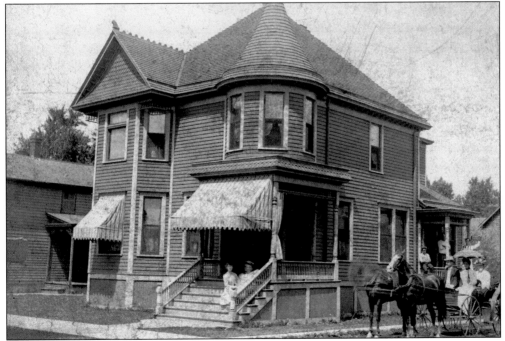

The Dr. Napoleon Langlois home on Eureka Avenue was a well-built structure. It appears that the family is ready to embark on a local excursion as they prepare to leave their residence in the horse-drawn carriage. (Wyandotte Museum.)

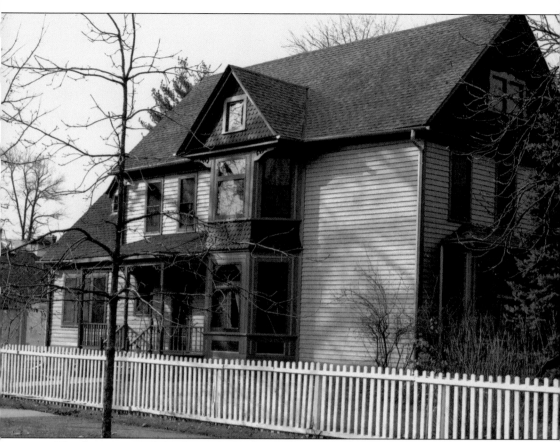

The first owners of this home located at 109 Vinewood Street were John and Emma Eberts. John Eberts Jr. was born in 1843 in a home in Detroit, the son of German immigrants, and in 1872 married Emma Lacey. That same year, the house was built by Raphael R. Thomas. It is a good example of a mid-Victorian cottage-style home. It had the second bay window in town and the first Crown Jewel baseburner coal stove. The Eberts lived many years in the house, which had beautifully landscaped gardens, including rock gardens maintained by Emma. (Wyandotte Museum.)

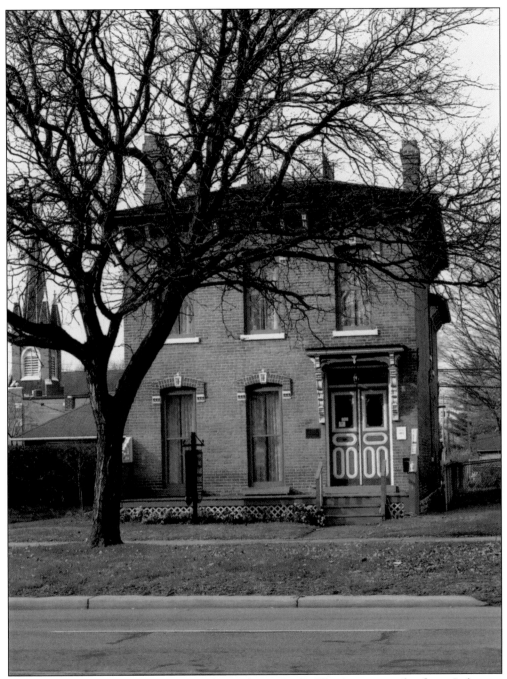

The Marx Home dates from 1862, is located at 2630 Biddle Avenue, and reflects Italianate architecture. Research conducted by the Wyandotte Historical and Cultural Commission indicates that the house originally stood on a larger site with an orchard located on the south side and a vegetable garden separating the orchard from the existing site. From 1870 to the early 1900s, the William Armstrong family lived in the structure. The Marx Home is listed on the National Register of Historic Places and owned by the City of Wyandotte. It serves as a museum and meeting facility for the Wyandotte Museum. (Wyandotte Museum.)

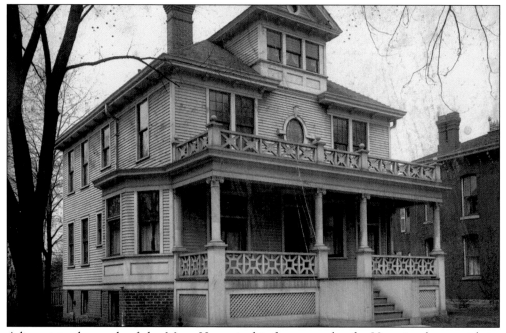

Adjacent to the south of the Marx Home is this fine example of a Victorian home with its Corinthian columns on the front porch and well-built chimney. Today it stands on its original site and adds to Wyandotte's architectural collection of fine homes. Note the Marx Home on the right in the photograph with its iron cresting at the very top of the building. (Wyandotte Museum.)

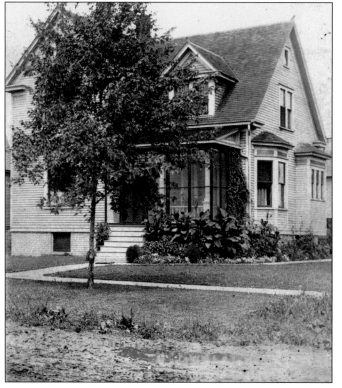

Jacob Kloeckner constructed his home in 1909 at the northwest corner of Walnut Street and Second Street. Kloeckner was a Wyandotte home builder by trade. Note all the interesting plantings around the front of the home. (Wyandotte Museum.)

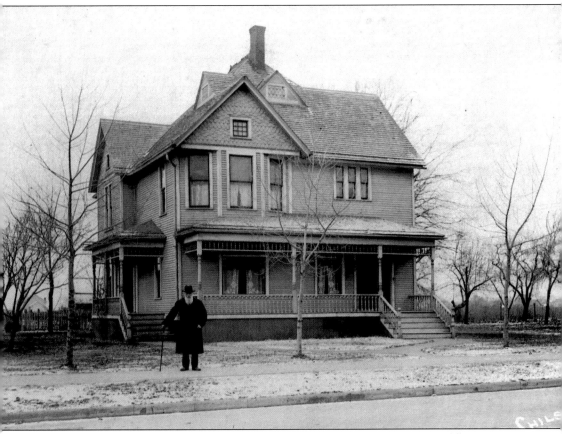

The Antoine Labadie Home was originally located at the northwest corner of Biddle Avenue and Antoine Street. Labadie was a member of an early French family that had settled in Ecorse Township. The house was later moved to 150 Spruce Street and remodeled. In this photograph, Labadie proudly stands in front of his home. (Wyandotte Museum.)

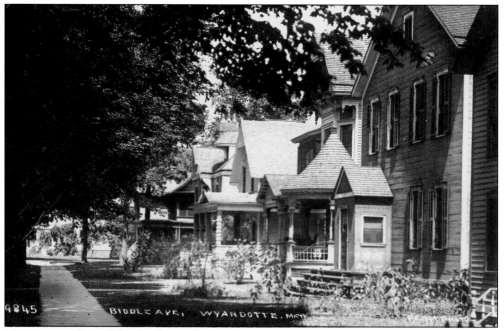

This is a sampling of the fine homes built in the 2500 block on the east side of Biddle Avenue. Each home had its own unique character, and local residents took pride in landscaping, as is evident by the plantings around the foundation of the homes. (Wyandotte Museum.)

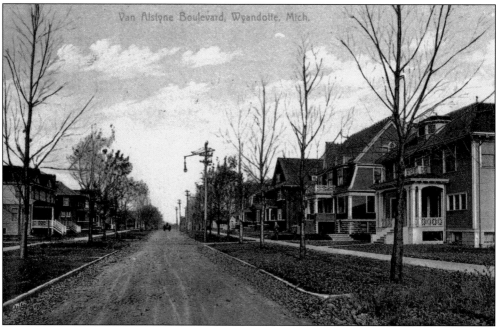

These grand homes along the Detroit River are large structures with several fireplaces. Homes on the east side of Van Alstyne Boulevard enjoy a beautiful view of the boats and waters of the Detroit River. In 1910, concrete sidewalks have been installed, but the road is not yet paved. (Wyandotte Museum.)

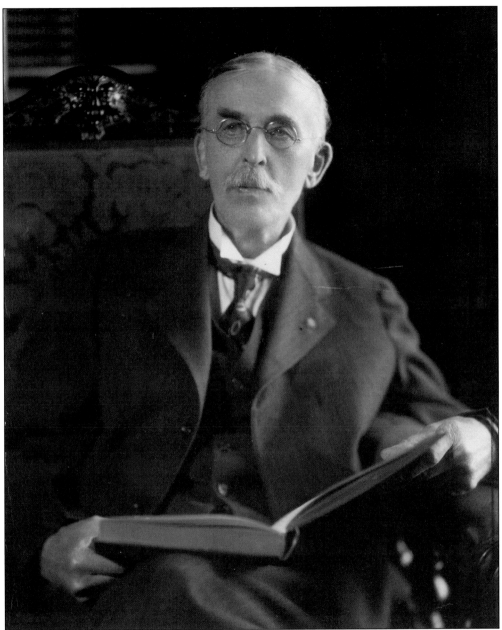

Jerome H. Bishop, manufacturer, schoolmaster, and philanthropist, assisted in advancing the growth of the city. The J. H. Bishop Company, Manufacturing Furriers, was developed from the manufacture of wool dusters and grew into one of the largest and most successful firms of its kind in the United States. Bishop invented many new processes especially for longhaired furs and did much to improve the appearance and usefulness of the cheaper grades. He was the first in the country to import raw skins from Russia and China and dye and dress them in his own factory. After 1900, Bishop gave up the fur business and devoted his time to real estate, building, and continuing his work in philanthropy. He also served five terms as mayor of the city, in 1885, 1886, 1905, 1906, and 1907, and was the founder of the First Congregational Church in Wyandotte. (Bacon Memorial District Library.)

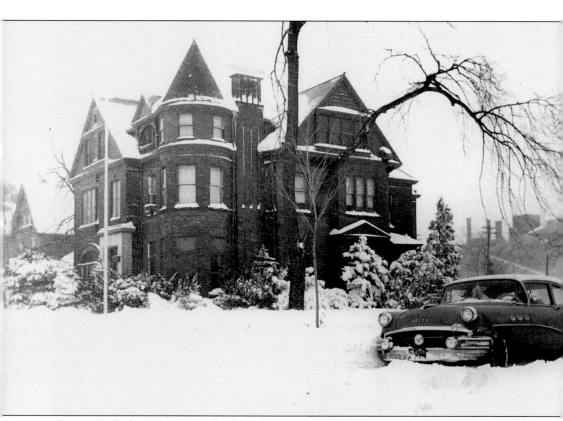

Jerome H. Bishop's home was built at the corner of Superior Boulevard and Biddle Avenue in 1887 and was recognized as the finest brick house in the city. The house had 20 rooms and 10 fireplaces and was generously paneled with red and white mahogany and quartered oak. Since these homes were not air-conditioned, Bishop had space left between the double outer brick walls, a technique that reduced the temperature in the summer 10 to 15 degrees and kept the house warm in winter months. Bishop died in 1928, and his home was acquired to serve as Wyandotte's city hall from 1935 until 1968. The home was later demolished during an urban renewal program to make room for a new federally funded housing project. (Wyandotte Museum.)

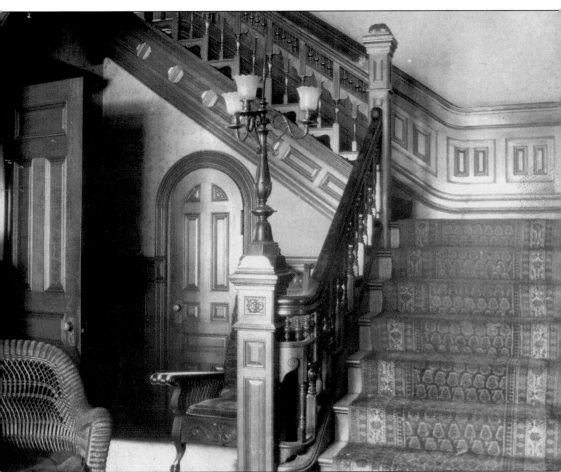

The Bishop home foyer as it appeared when the house was being used as a private home was a warm and inviting reception area. An elaborate light fixture was mounted on the staircase newel post with stairs carpeted in rich wool and elegant woodwork around the perimeter of the room. The home was designed by architect Gordon Lloyd. The first-floor rooms featured parquet flooring, and the third floor contained a highly polished dance floor, a decorative 10-foot mirror with Victorian furniture in a small sitting room, and an adjoining balcony. The Bishop home hosted many social events and was a prime example of Wyandotte's distinctive homes along Biddle Avenue. (Wyandotte Museum.)

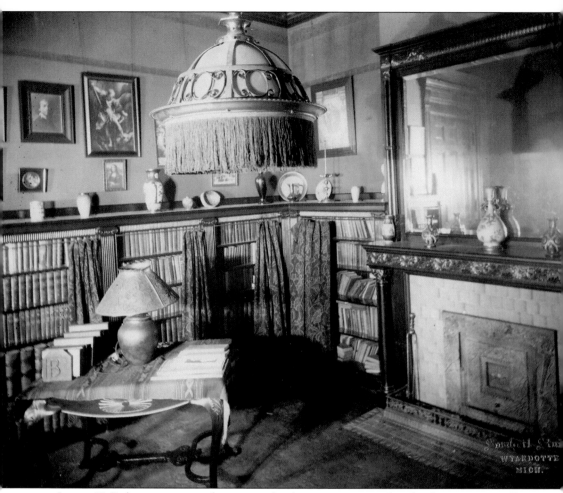

Jerome H. Bishop was extremely interested in literature, as is evident by the extensive collection of books in the Bishop home library. The shelving has drapery to protect the volumes from dust and fading from light exposure. It would be interesting to know the title of each rare volume in this library. The ornate hanging light fixture allowed the reader to move a chair directly under the light. (Bacon Memorial District Library.)

The Ford-Bacon Home, designed by the noted Detroit architectural firm of Malcomson and Higginbotham, was built in 1897 on the southeast corner of Biddle Avenue and Vine Street (later to be changed to Vinewood Street in 1928). Mary Ford Bacon was the granddaughter of J. B. Ford. Mark Bacon was a lawyer and served in 1917 as a member of the U.S. House of Representatives. They lived in their family residence from 1902 to 1942. In later years, the Bacons spent a considerable amount of their time living in California. When Bacon died, his wife deeded the home to the Wyandotte School District for use as a public library or other educational purpose. (Bacon Memorial District Library.)

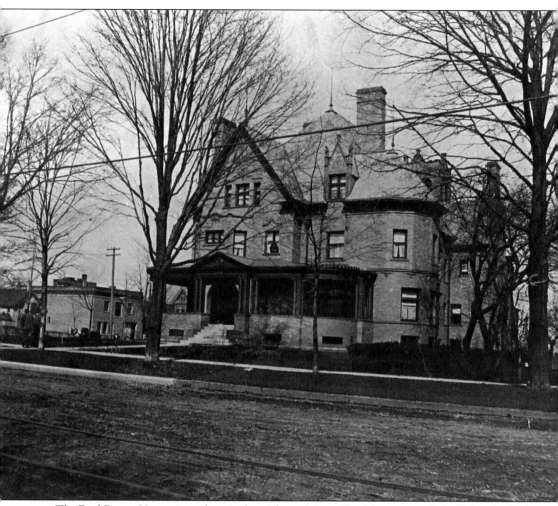

The Ford-Bacon Home sits on four city lots. The architects' final design specified a 62-foot-by-95-foot building that included 27 rooms and 11 fireplaces. The Queen Anne–style home incorporated the modern conveniences of the time and used the finest construction materials available. The Ford-Bacon Home exterior features buff-colored St. Louis hydraulic-pressed brick with red sandstone trim. The wide front porch extends along the north and west sides of the home, which has an observation tower on the east side that offers an impressive view of the Detroit River. The house was originally topped with a black slate roof. (Wyandotte Museum.)

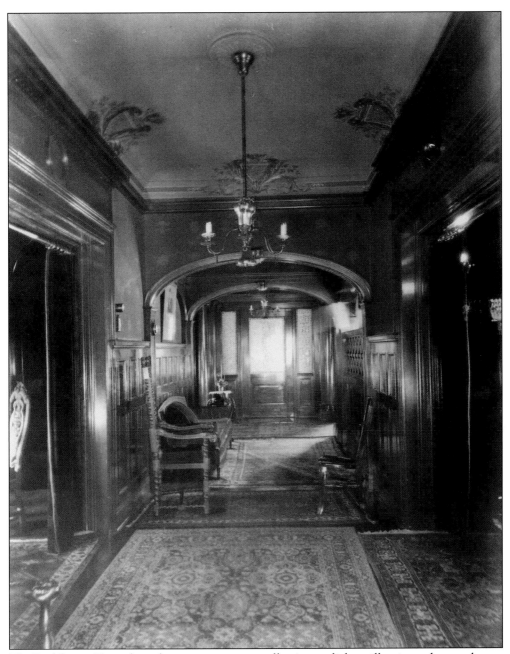

The Ford-Bacon Home faces the western exposure, allowing sunlight to illuminate the grand entry hallway. The area was well appointed with fine quality oak wood, and the floor complemented the oriental rugs running the length of the hall. The ceiling offered ornate painted designs with decorative light fixtures. The entry door to the hallway was made of heavy oak with the door encased by leaded glass panels on each side. The reception room off the hallway was decorated in the oriental style. In this 1905 view, note the drawing curtains in the doorway of each room that could be drawn for privacy. (Bacon Memorial District Library.)

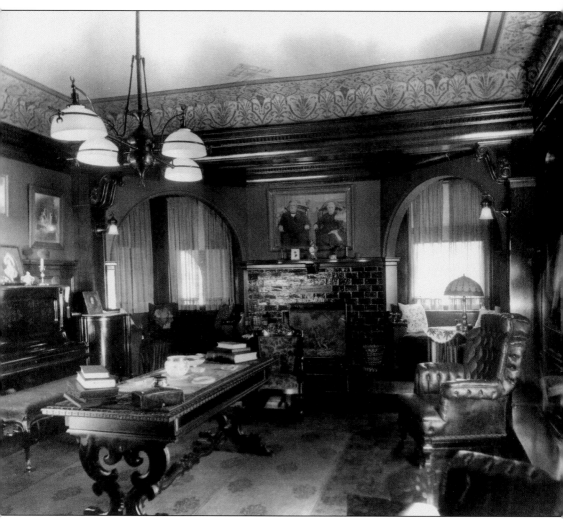

The billiard room offered window seating along two sides of the room and beautiful oak paneling. Note the large light fixture hanging over the library table and the fine appointed seating in the room. Side light fixtures mounted on the walls contributed additional light. In this 1905 photograph, a piano and music cabinet offer an opportunity to enjoy musical favorites of the family. (Bacon Memorial District Library.)

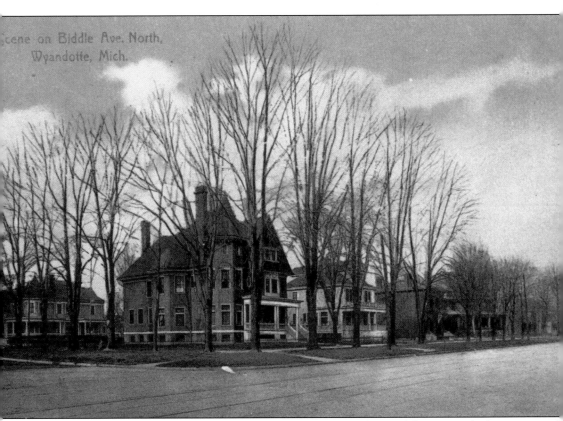

This is a fine illustration of the interesting Victorian homes located on Biddle Avenue looking north in Wyandotte. The J. B. Ford home at the corner of Biddle Avenue and Superior Boulevard in the foreground was demolished many years ago to make way for a new business. The other homes pictured along Biddle Avenue are still standing on their original sites, reflecting the original architectural setting for the quality of homes along the "main street." (Wyandotte Museum.)

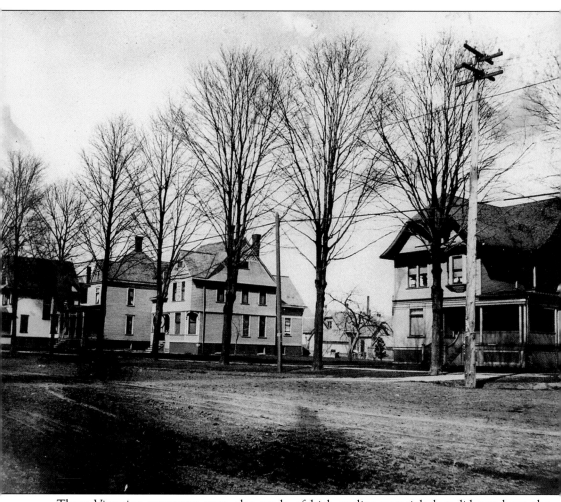

These Victorian structures were also made of high-quality materials but did not have the extensive brackets, gingerbread, or elaborate landscaping on the buildings and grounds. The homes were located along Biddle Avenue at Poplar Street, and at the time these homes were captured on film, Biddle Avenue had not yet been paved. (Bacon Memorial District Library.)

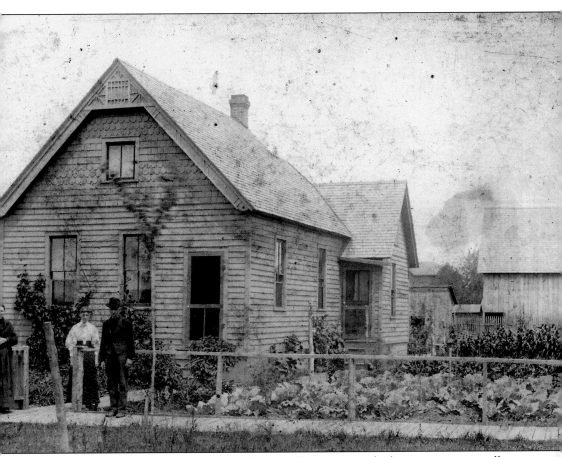

Along with the more spacious homes located on Biddle Avenue and adjoining streets, smaller homes could also be found around the periphery of the downtown business district. This cottage-style home provided all the necessary comforts of living without major embellishments. These home owners planted a vegetable garden conveniently next to their home, and based on the appearance of the garden and the size of the plantings, the soil must have been rich. A simple rail fence with some chicken wire managed to keep out hungry rabbits. (Bacon Memorial District Library.)

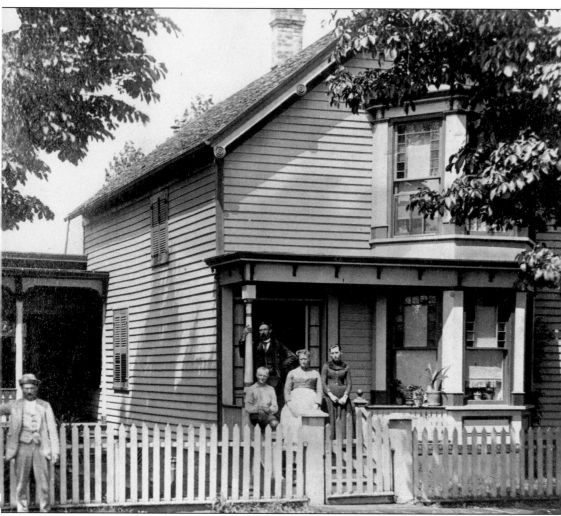

The Girardin home is another interesting example of a businessman's abode. The house had colored glass panes flanking a piece of clear glass in the upper portion of the windows, simple decorative architectural elements around the roof of the porch, and a well-built fence with a swinging gate. The residents posing for the camera include, from left to right, Aaron Strong, Joseph Girardin Sr., William Girardin, Mrs. Joseph Girardin Sr., and Lena Gee. (Wyandotte Museum.)

Five

CULTURAL LIFE AND GROWTH OF THE CITY

Prior to 1880, formal chartered organizations were not in abundance in the community. Families would gather and exchange ideas around the family table in the pioneer homestead. The women would trade recipes and discuss family matters while the men would often gather in a separate room, smoke their pipes, and play a game of dominoes while they discussed the day's work activities and politics. Many times the men would also take their discussions to the local saloon and catch up on the day's events. Wyandotte has been fortunate over the years to have so many cultural groups that have contributed to the growth of the city, including churches, singing societies, a community chorus, dramatic groups, and literary groups. In addition, there were many recreational activities that allowed local residents to enjoy the benefits of the Detroit River waterfront. The cultural groups exceeded well over 100 organizations with the ethnic groups of the English, Irish, Scotch, Germans, Italians, and Polish contributing significantly to the continuing growth of the city, which has played a major economic role in the development of this country.

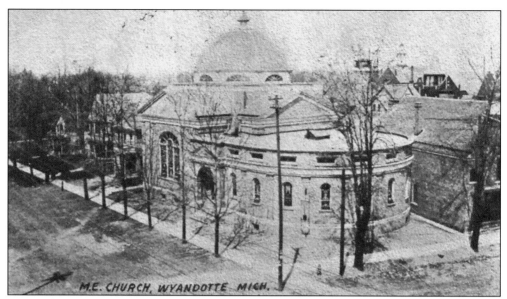

During the early village life of Wyandotte, the Methodists formed their congregation at a home on Elm Street. After several months, the meetings were transferred to the Old Brown School on Chestnut Street with the services being conducted according to the New England practices. The first Methodist church building was built in 1861 in a New England–style architecture. In later years, plans were made to build a larger church that would serve the needs of the congregation. The unique circular shape of this new house of worship was an exciting concept. (Wyandotte Museum.)

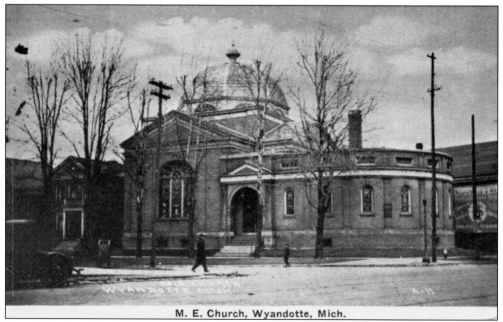

The Methodist church was located at the corner of Oak Street and Biddle Avenue in the downtown business district. The shape of the building projected a rounded exterior and greatly complemented the streetscape of the area. A visitor traveling north on Biddle Avenue would certainly notice this well-designed structure. (Wyandotte Museum.)

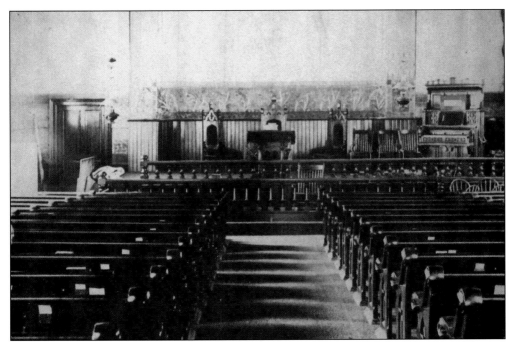

An interior view shows the First Methodist Church in 1861. Some fiery sermons delivered from this pulpit prompted some of the members of the congregation to leave and join the Congregational Church of Wyandotte. (Bacon Memorial District Library.)

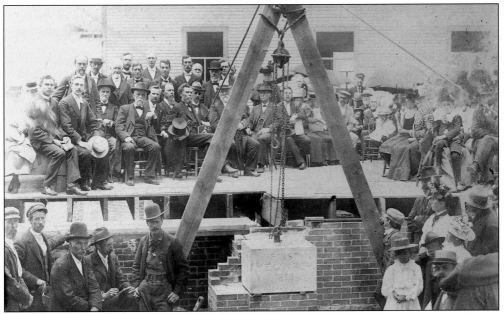

An exciting day in the life of some local residents was the laying of the cornerstone for the First Methodist Church in 1899. The new building with the rounded design was dedicated on November 26 of the same year. In 1964, the building was razed to make way for a new church. The First United Methodist Church was constructed at the same location. (Bacon Memorial District Library.)

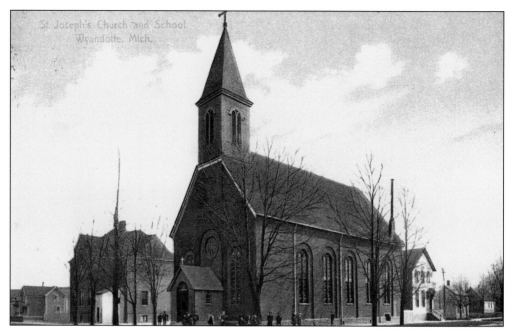

In 1870, German members of St. Patrick's congregation concluded that they preferred a church in which the German language would be used and wanted a church that would recognize their cultural requirements. The church was organized as St. Joseph and was built in 1871. (Wyandotte Museum.)

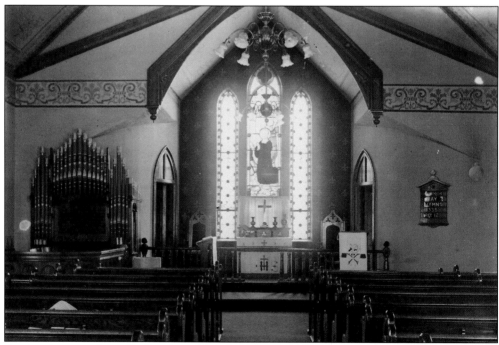

An interior view shows St. Stephens Church from between 1879 and 1902 with the pipe organ at the front of the church and decorative painting inside the sanctuary. Note the ornate light fixture hanging over the pews. (Bacon Memorial District Library.)

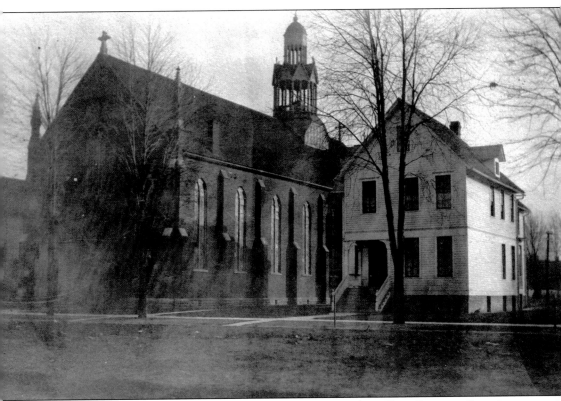

In 1857, St. Charles Roman Catholic Church was constructed on First Street at Superior Boulevard, the present site of St. Patrick Church. The church building was moved west to the corner in 1873 to allow construction for a larger brick church with stained-glass windows. The old St. Charles Roman Catholic Church building was then used as a school. This is a view of St. Patrick Church located on the south side of Superior Boulevard with an open steeple as it appeared in 1900. (Wyandotte Museum.)

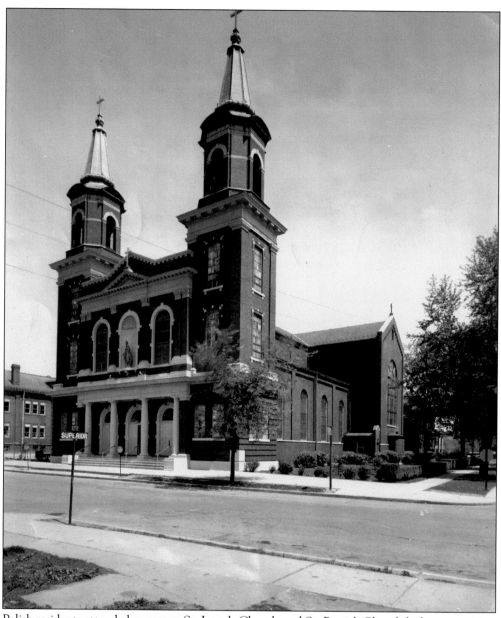

Polish residents attended masses at St. Joseph Church and St. Patrick Church before organizing Our Lady of Mount Carmel Church in 1899. The church, located at Superior Boulevard and Tenth Street, held its dedication on July 8, 1900. The present church was constructed in 1915. (Wyandotte Museum.)

The Old Central High School on Oak Street was constructed in 1869. The school was a New England–style three-story brick structure that had two front entrances and six rooms and seated 340 pupils. It was Wyandotte's first high school. Daniel Thomas was the first superintendent, and the first class consisted of five girls. (Bacon Memorial District Library.)

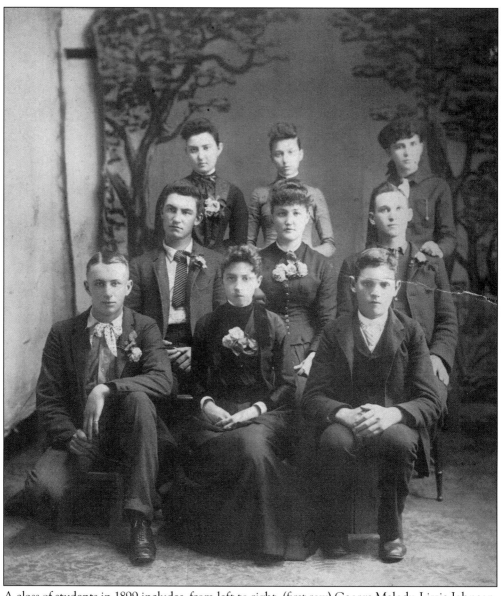

A class of students in 1899 includes, from left to right, (first row) George Melody, Lizzie Johnson, and Fred Van Alstyne; (second row) Will Campau, Nell Sutliff Webb, and Sam Vreeland; (third row) Blanche Lacy, Mabel Clark, and Molly White. (Wyandotte Museum.)

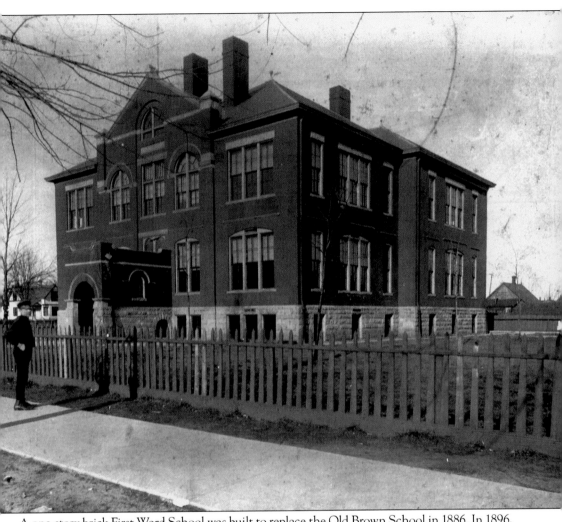

A one-story brick First Ward School was built to replace the Old Brown School in 1886. In 1896, two more rooms were added to the building, and in 1898, it was torn down and replaced by a new structure with eight classrooms and two basement rooms. (Wyandotte Museum.)

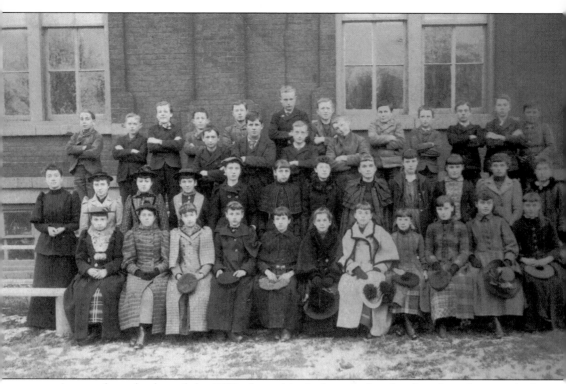

A seventh-grade class of the 1890s dressed in its best clothes for this class photograph. It is interesting to note that all the boys are standing with their arms folded and several girls are wearing or holding their hats in a more relaxed pose. Some of the students wore black, with others wearing clothing reflecting a variety of patterns. (Wyandotte Museum.)

Some affluent families in Wyandotte were able to provide their children with many fine amenities. It is believed that the horse-and-carriage cart is carrying the Hurst family twins on Biddle Avenue in 1892. (Bacon Memorial District Library.)

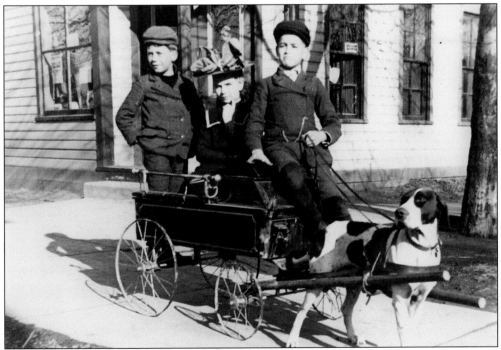

Robert Burrell, Howard Clark, Lila Fairchild, and a four-legged friend take a stroll along the sidewalk. The children are well dressed, and the young girl even has an elaborate hat for the excursion in 1900. (Bacon Memorial District Library.)

As Wyandotte continued to grow culturally, local residents deemed it important to have a public library. With the opening of the high school in 1869, a collection of books became available for public use at the high school library. The use of these books proved popular, and in 1874, under superintendent Jerome H. Bishop, the library sought its own identity by moving to the second floor of the Wyandotte Savings Bank building. At that time, the book collection consisted of several bookcases of fiction and nonfiction books, children's books, and encyclopedias. Ida Bolton was hired as a librarian-clerk sometime in the 1870s. She was paid $1 per month for her weekly one hour of work. (Bacon Memorial District Library.)

Bishop continued to pursue his interests in building a library for Wyandotte, and in October 1886, the library reading room officially opened in the city hall. Nellie Briggs became Wyandotte's first full-time librarian. (Bacon Memorial District Library.)

Briggs passed away in 1896, and the board of education elected Lillian Rogers to the position of city librarian. The community was proud of its library, and, from time to time, special fund-raising events were held at the Marx Opera House and other locations to support the library. Rogers stands in the reading room of the library. (Wyandotte Museum.)

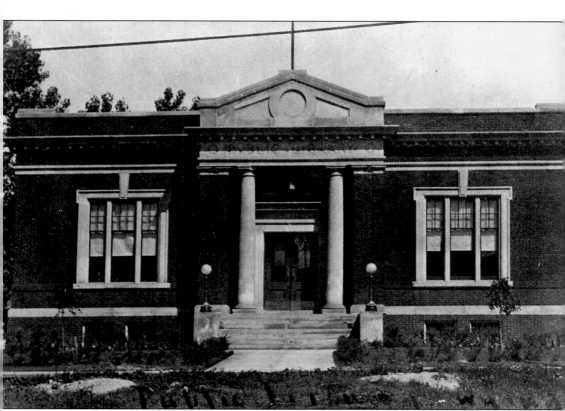

In 1910, it was determined that the city would seek a Carnegie grant for a new library to be located at 3139 Biddle Avenue on the east side. The building was designed by H. B. Wetzel of Detroit and consisted of a one-story building with a basement. It was constructed of red brick and had stone trimmings. It was designed to accommodate 8,000 volumes and also offered an assembly room and reading room. The formal dedication of the building was held on May 15, 1915. (Bacon Memorial District Library.)

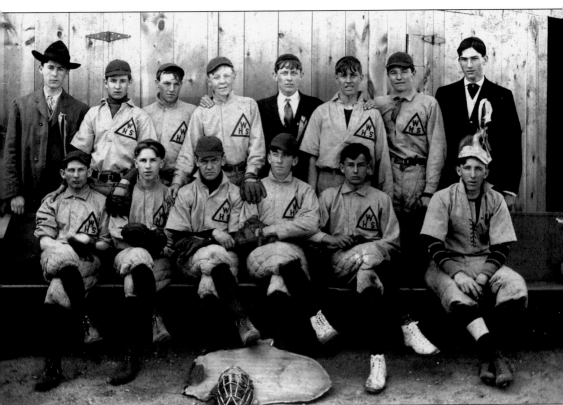

Wyandotte residents pursued other areas of interest, including sports. The Wyandotte High School baseball team of 1905 includes (first row) Steward Adair, Fred Berndt, Leo Hammel, William Cummings, Ralph Clark, and Harry Mehlhose; (second row) Earl Vorman, Harrison Woodruff, ? Townsend, Stephen Orr, Harry Pinson, Walter Eberts, Fred Reig, and Charles Johnson. (Bacon Memorial District Library.)

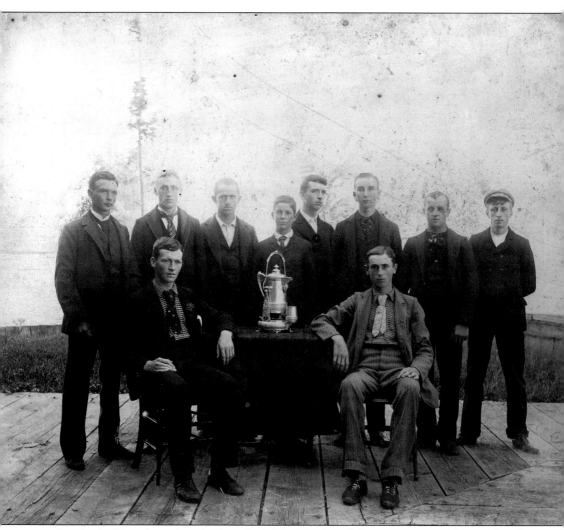

Rowing in Wyandotte dates back to the 1870s. The *Jesse B* boat crew won a silver pitcher during the Fourth of July race in 1876. Edward Bryan was the builder and owner. The race was sponsored by the Ancient Order of Hibernians. Pictured from left to right are (first row) unidentified and Roy Armstrong; (second row) Jim Bryan, Harry Wilkerson, unidentified, Elton R. Hollis, Barter Ebert, Dr. Napoleon Langlois, John Denwan, and Archie Dements. This was the first race ever won by the oarsmen. (Bacon Memorial District Library.)

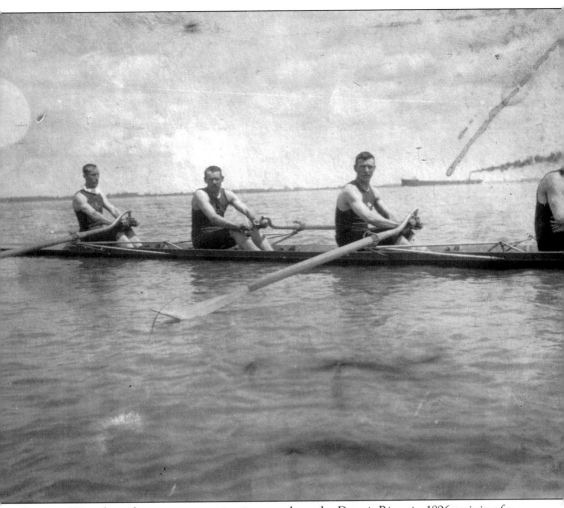

This is a Wyandotte four-oar crew rowing its way along the Detroit River in 1896 training for upcoming competitions. The rowing shirts' insignia identifies the team during races as the "Y&." crew. Oarsmen are seated very close to the water in these rowing shells. (Wyandotte Museum.)

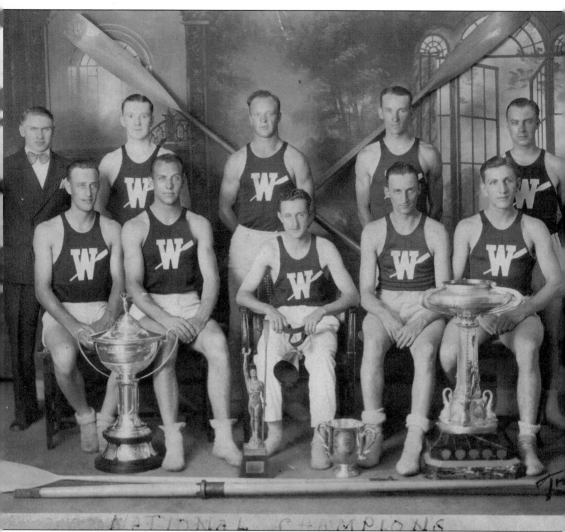

In 1892, a rowing crew won the Championship of America title at Saratoga Springs, New York. Wyandotte continued through the years to be noted for its outstanding oarsmen. On August 6, 1927, these crew members won the race competition and captured the title of the national champions of the United States and Canada. The members of the team include, from left to right, (first row) Roy Simpson, Arman Roth, Lynn Bryan, Milton Moore, and Robert Gerth; (second row) Clyde Ludwig (trainer), James Mason, Columbus Bourassa, William McClenahen, and Case Baisley. (Wyandotte Museum.)

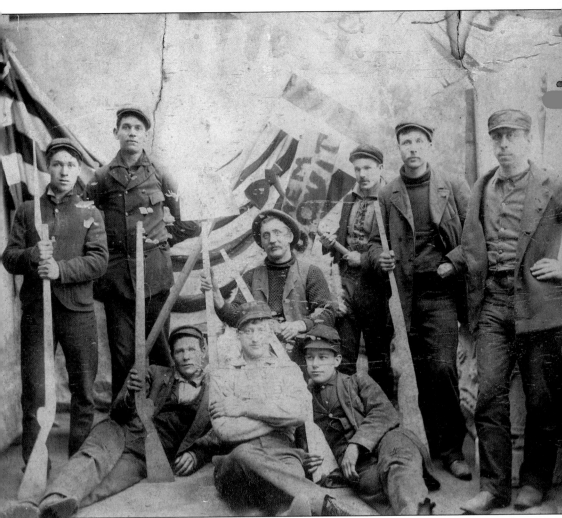

Another group that was part of the many organizations in Wyandotte comprised of local residents included the Street Gun Club. This group was active in the 1890s. Participants in this group include, from left to right, (first row) William Nausett, Joe Pinson, and unidentified; (second row) John Clark, Frank Betree, Henry Wilkinson, unidentified, John Clements, and Frank Nave. (Bacon Memorial District Library.)

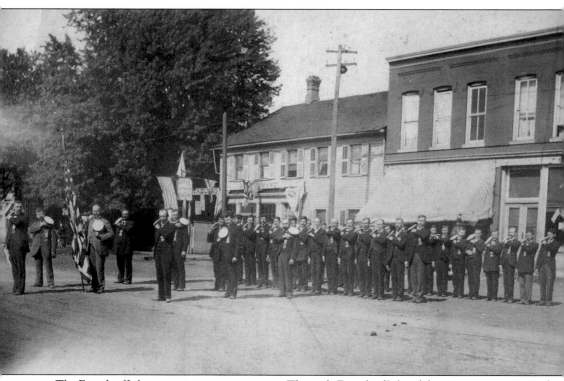

The Fourth of July was an important occasion. The early Fourth of July celebrations were conceived and sponsored by citizens of German origin through the Arbeiter Society. The Germans were strongly patriotic, and since the Arbeiter Society was a very influential organization in the community, their leadership in societal activities was welcomed. The Arbeiters are preparing for the parade at the corner of Oak Street and Elm Street in front of the Detroit Exchange Hotel. (Wyandotte Museum.)

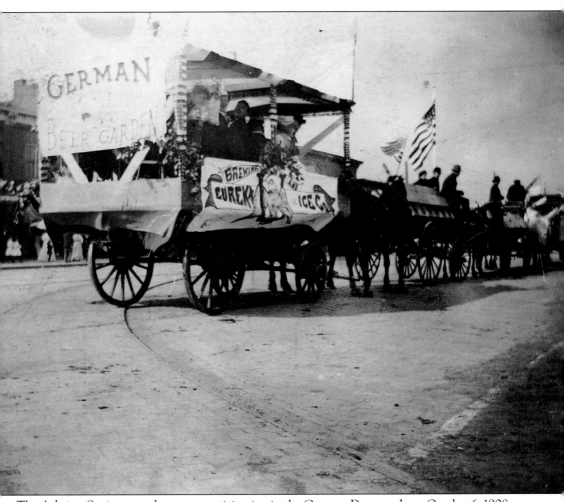

The Arbeiter Society parade wagon participating in the German Day parade on October 6, 1908, travels through downtown Wyandotte to celebrate German traditions. The banner on the side of the wagon promotes the Eureka Brewing and Ice Company. (Bacon Memorial District Library.)

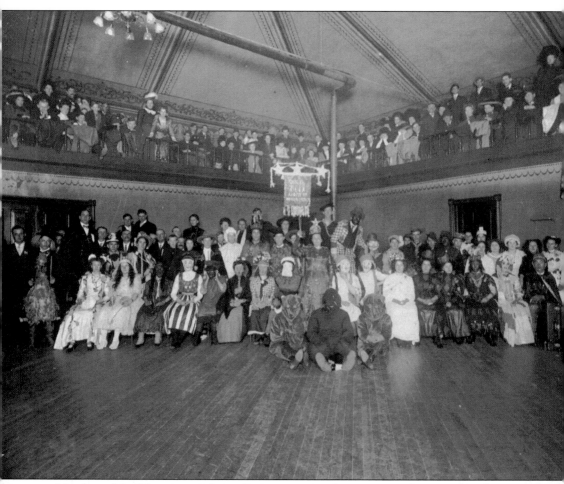

Members of the Wyandotte Arbeiter Society enjoying their masquerade party take a few moments to pose for a group photograph in Arbeiter Hall. Many of the costumes are quite elaborate. Some promoted patriotism while others chose not to come dressed in a costume but attended to join in on the fun. (Wyandotte Museum.)

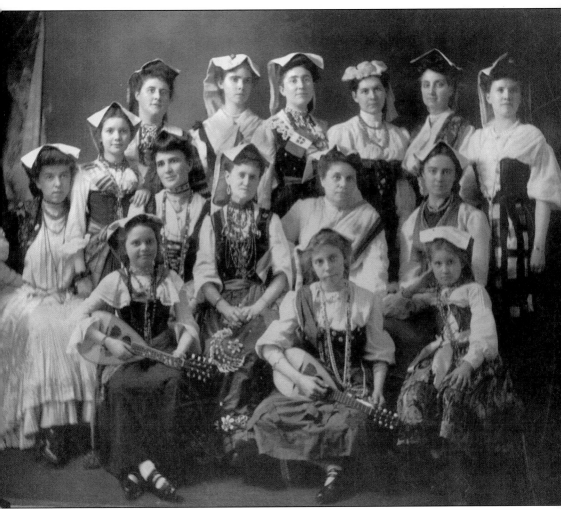

The Tuesday Study Club was organized in 1899 for the purpose of intellectual and social culture and a united effort toward the attainment of higher ideals in thought and life. Many civic activities of philanthropic, educational, and social needs were supported by the Tuesday Study Club. Its general activities also included petitions for better street railway service, the development of Bishop Park, the organization of the Girl's Club, and a recreational survey to determine the needs of the city. These members of the Tuesday Study Club are celebrating Italy Day in 1904. (Wyandotte Museum.)

There is very little historical information available about the Daffodil Club, but many of Wyandotte's well-known family names comprised the membership rolls. Note that all the ladies are wearing daffodils pinned to their dresses. This is an example of one of the many organizations formed to promote social activity within the city. (Bacon Memorial District Library.)

In the summertime, picnics replaced dancing as a favorite social activity. Many of the picnics offered a program of music. One such group was the Denman Family Band, comprised of members of one family. These include (from left to right) William Denman, Mr. Denman, Belle (Denman) Baisley, John Denman, Bertha (Denman) Goodell, and Charles Denman. All five of Mr. Denman's children played in the band. (Bacon Memorial District Library.)

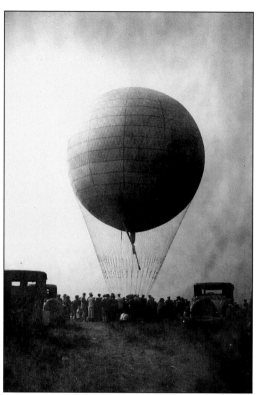

Another exciting and fascinating event was the launching of a hot air balloon. Balloon ascensions offered the local residents a chance to obtain a bird's-eye view of downtown Wyandotte. These ascensions departed from the corner of Biddle Avenue and Pennsylvania Road. (Bacon Memorial District Library.)

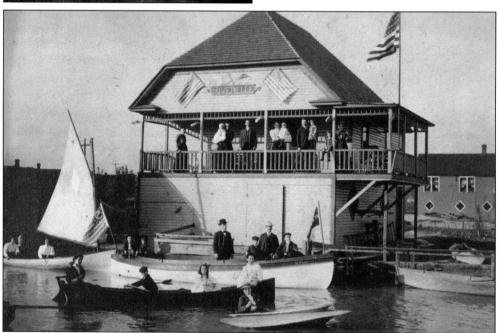

Boating in Wyandotte offered another opportunity to socialize and visit with other members of the local community and out-of-town visitors, enjoy the Detroit River, and attend musical events at picnics after boating on the water. The Daniel family summer cottage and boathouse was built around 1910 and was located at the foot of Orange Street. (Wyandotte Museum.)

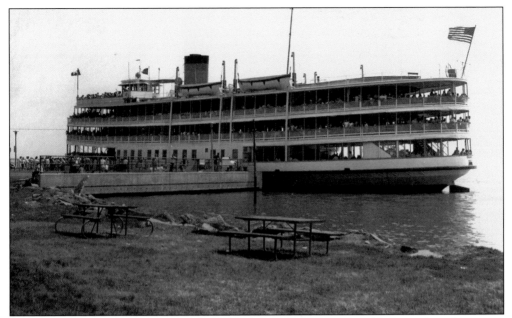

The Bob-Lo excursion steamers included the *Ste. Claire* and SS *Columbia* and made trips to Bob-Lo Island and recreational jaunts on the Detroit River. The SS *Columbia*, built in 1902 and designed by Frank E. Kirby, was a propeller-driven excursion steamer. It is the oldest passenger steamer in the United States and is listed as a national historic landmark vessel. (Wyandotte Museum.)

The first railroad train in 1855 passed through the western limits of the village of Wyandotte and was named the Detroit, Monroe, Toledo Railroad. In 1890, this line became known as the Toledo branch of the Lake Shore Michigan Southern Road, later consolidating with the New York Central. From 1855 to 1865, a boxcar was used as the depot until a wooden structure was built. This structure was not adequate, and a new union depot was completed in 1891 for joint use by the Lake Shore and Michigan Central Railroad. This depot, located along Oak Street, is still in use today, although not as a railroad depot for passengers. The station was also host to two United States presidents: Pres. Theodore Roosevelt in 1902 and Pres. William Clinton in 1996. (Bacon Memorial District Library.)

BIBLIOGRAPHY

DeWindt, Edwina and Joseph. *Our Fame and Fortune in Wyandotte*. Wyandotte, MI: Wyandotte Rotary Club, 1985.

DeWindt, Edwina. *Proudly We Record*. Wyandotte, MI: Wyandotte Rotary Club, 1955.

Dickie, Rev. James F., D. D. *Reminiscences of Detroit*. Lansing, MI: Michigan Historical Commission, 1930.

The Downriver Community Conference Architectural and Industrial Survey. Wyandotte, MI: Downriver Community Conference, 1979.

Hayden, Wallace. *The History of the Public Library in Wyandotte, Michigan*. Wyandotte, MI: Bacon Memorial District Library, 2006.

Illustrated Historical Atlas of the County of Wayne Michigan. Chicago: H. Belding and Company, Lakeside Building, 1876.

Lewandowski, Stephen. *Farmer's and Housekeeper's Cyclopaedia, 1888*. Trumansburg, NY: The Crossing Press, 1977.

Pound, Arthur. *Salt of the Earth: The Story of Captain J.B. Ford and Michigan Alkali Company*. Boston: Atlantic Monthly Company, 1940.

Wyandotte Historical Society. *Wyandotte: A Pictorial History—The Early Years*. Wyandotte, MI: Wyandotte Historical Society, 1997.

Wyandotte, Michigan Centennial, 1854–1954: Official Souvenir Program. Wyandotte, MI: Centennial Committee, 1954.

Wyandotte Past, Present, Future, 1854–1917. Wyandotte, MI: Wyandotte Historical Society and Wyandotte Museum, 2000.

Wyandotte—75 Years of Good Clean Living. Wyandotte, MI: BASF Wyandotte Corporation.

INDEX

DISCOVER THOUSANDS OF LOCAL HISTORY BOOKS FEATURING MILLIONS OF VINTAGE IMAGES

Arcadia Publishing, the leading local history publisher in the United States, is committed to making history accessible and meaningful through publishing books that celebrate and preserve the heritage of America's people and places.

Find more books like this at
www.arcadiapublishing.com

Search for your hometown history, your old stomping grounds, and even your favorite sports team.

Consistent with our mission to preserve history on a local level, this book was printed in South Carolina on American-made paper and manufactured entirely in the United States. Products carrying the accredited Forest Stewardship Council (FSC) label are printed on 100 percent FSC-certified paper.

MADE IN THE USA